Neue Pinakothek
Munich

by
Veronika Schroeder

Prestel
Munich · London · New York

Table of Contents

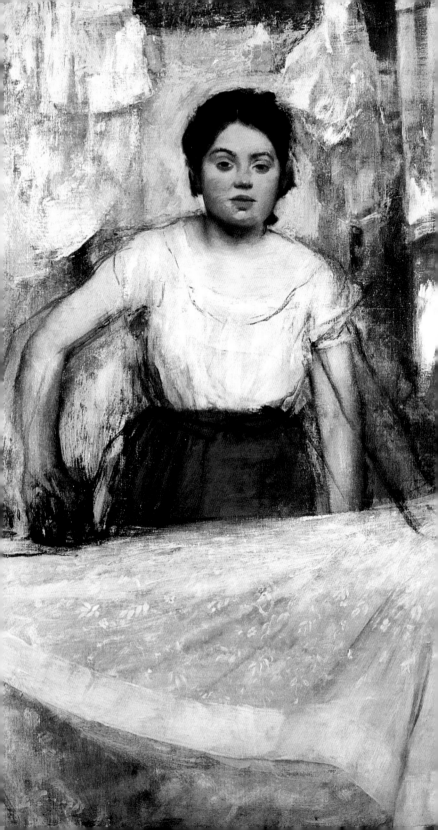

The History of the Founding of the Neue Pinakothek and Its Collection

The Neue Pinakothek was the third of three galleries built in Munich by King Ludwig I of Bavaria, following the Glyptothek and the Alte Pinakothek. Designed to house paintings of the 19th and subsequent centuries, the building was based on the plans of the architect Friedrich von Gärtner and executed by August von Volt. Unlike the first two galleries, which were designed by Leo von Klenze and reconstructed after being bombed during the Second World War, the Neue Pinakothek, which suffered far less damage, was demolished in the early 1950s despite its importance as a typical example of von Gärtner's architectural style. In 1981, a new structure was built by Alexander von Branca on the same site. Besides administration offices and workshops, it houses the international collection of the Neue Pinakothek, with works of art dating from the late 18th century to the early 19th century.

The collection dates to the early 1830s, when King Ludwig I began to show an increased interest in contemporary art, having previously devoted his attention almost entirely to the art of classical antiquity and the Old Masters. In 1868, when Ludwig I died, his collection of contemporary art – financed exclusively from the privy purse – already numbered 395 items. The Munich School, of course, occupied pride of place, although the works of Cornelius and a number of other important artists were not represented. As history painters, they had been mainly responsible for large-scale murals in public buildings.

Ludwig I's son and successor, King Maximilian I Joseph, collected the works of landscape painters such as Dorner the Younger, Dillis, and Wagenbauer, whose honest depictions of nature were reminiscent of 17th-century Dutch painting. Works by the younger generation of painters, including Kobell, Bürkel, Adam, Peter Hess, and Neher, also began to find their way into the Königliche Neue Pinakothek after being exhibited in the Kunstverein, a society for the promotion of the fine arts. In the hierarchy of artistic categories still upheld in the academies at that time, landscape painting occupied a lower position – together with genre scenes and still lifes – and artists who executed such works were disparagingly referred to as *Fächler* or speciality painters. With the purchase of works by non-Bavarian newcomers such as the landscape painters Ezdorf, Morgenstern, and Andreas Achenbach, who belonged to the Munich School, at least for a time, the collection came to include art by important figures from northern Germany; and with his acquisition of works by artists from the German School in Rome, Ludwig I extended the range of his collection far beyond local boundaries. After his second visit to Rome, the king felt a close affinity with the circle of painters

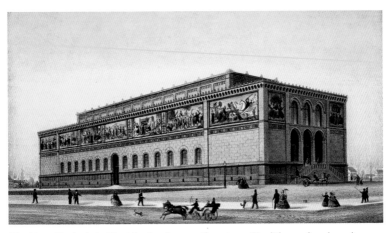

The Neue Pinakothek, Munich, view from south-east, c. 1865, lithograph, coloured crayon, one of a series of 18 views of Munich published by Max Ravizza. Collection of the Stadtmuseum, Munich, Inv. No. Z(A7)1115

around Josef Anton Koch and Friedrich Overbeck, who were inspired by classical Italian landscape painting and the works of Raphael and his artistic predecessors. It would be otherwise inconceivable that the Neue Pinakothek should possess so many important pictures by this circle of painters, not to mention the unique collection of Rottmann landscapes that were executed largely in the form of monumental murals, with depictions of the historical regions of Italy and Greece.

Indeed the international stature of Ludwig I's collection can be measured by the relatively high proportion of works it contains by non-German artists. In comparison to the collections of other princely houses in Europe, the royal gallery in Munich possessed a truly cosmopolitan body of work, rivalled at that time by only a few private collections – a fact that might hardly be expected of a ruling monarch in a period of restoration. By the early 1840s, classical art, distinguished by

its poetic contents and finely drawn outlines, had been superseded by the works of Belgian and French painters who had rediscovered a bolder form of coloration. Ludwig I sought to acquire a number of these new pictures in the hope that they would inspire the painters at the Munich Academy, who were still following the linear style of Cornelius. Ludwig did so, even though the new style was not in accordance with his personal taste. Names such as Gallait, Navez, and Robert might be mentioned in this context. The painting *Seni before the Body of Wallenstein* by Karl Piloty is evidence of the fact that these new ideas ultimately had an effect in Munich and led to a change of direction. At the time, Piloty's work was regarded internationally as a sensation, and the king purchased this particular painting for his new gallery in the year of its completion. The picture opened a new chapter in the history of the Munich School of painting, which had risen to international

fame since the time of Cornelius. Once more, young painters from all over Germany, and the rest of the world, came to the city in large numbers to study at the Academy, where Piloty enjoyed an enormous reputation as a teacher and head of that institution.

In 1859, a year after purchasing the *Seni*, Ludwig I made a final important acquisition: Böcklin's early colouristic masterpiece *Pan amongst the Reeds*. The painting depicts a theme that was to be of pioneering importance for modern art: the reflection of psychological moods and dreams. The broad range of the works collected by Ludwig I for the Neue Pinakothek – from his early purchases of contemporary art to the final acquisitions –

reveals a sense of quality and didactic purpose, as well as a prescient cosmopolitanism that is exceptional for the time. The works also show an impartiality that is not found among his successors to the throne of Bavaria for many decades. Only in 1909, under Hugo von Tschudi – whom the Prince Regent Luitpold summoned from Berlin to become the curator of the collection in Munich – did a new phase of acquisitions of major importance begin. The works acquired by Tschudi, including many masterpieces of French Impressionism and postimpressionism, document the history of European painting in an exemplary manner.

Christoph Heilmann

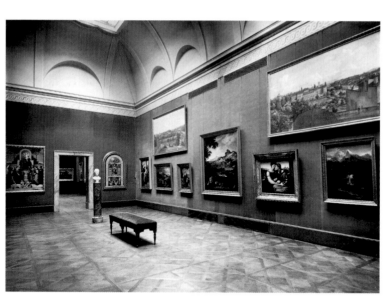

Hall of the Romantics and Nazarenes in the Neue Pinakothek, 1933, photograph

Two Generous Donations

At the turn of the century, the Bavarian State Painting Collections benefited from two exceptional donations that permanently enriched the Neue Pinakothek.

The Fiedler Donation

In 1891, Conrad Fiedler (1841–1895), a friend and patron of the arts, donated fifteen paintings, two large pastels and two cartoons by Hans von Marées (1837-1887) to the collection. These were followed in 1892 by three portraits by the same painter. His total donation included the triptychs *The Hesperides*, *The Courtship*, and *The Three Riders*, which are among Marées' principal works, as well as both versions of his *Golden Age*. From 1869 on, following Marées' break with his patron Count von Schack, Conrad Fiedler generously supported the artist, who in return regularly gave his benefactor paintings as a token of thanks. Fiedler's support of Marées was necessary, since the latter's work was appreciated by only a small circle of fellow artists. In fact, it was only through the enthusiasm and indefatigable efforts of Julius Meier-Graefe that Marées was ultimately accorded the recognition he deserved in the modern history of painting. Fiedler's donation – which was

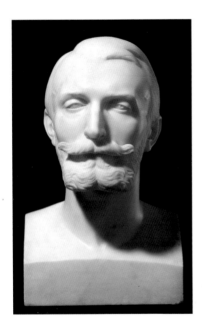

Adolf von Hildebrand, Bust of Conrad Fiedler, *1874–75, marble, h. 44 cm (B.295)*

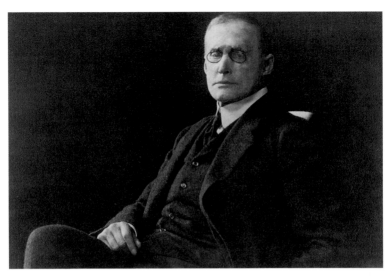

Hugo von Tschudi, c. 1900

later enhanced by gifts of Marées' works from other owners – was initially not exhibited in the Neue Pinakothek, but in the gallery of Schleissheim Palace, some distance from Munich. In 1913, Heinz Braune, an assistant to Hugo von Tschudi, brought the pictures to Munich, where he exhibited them in the context of a rearranged gallery. This reorganization also benefited the second major donation.

The Tschudi Donation

As a young man, Hugo von Tschudi (1851–1911) had been closely acquainted with the circle around Hans von Marées in Italy. After 1896, in his position as director of the National Gallery in Berlin and with the encouragement of Max Liebermann and Julius Meier-Graefe, von Tschudi sought to enlarge the collection with more recent French works; indeed, he attempted to found a new department for that purpose. His efforts roused the antagonism of Wilhelm II and a number of contemporary German artists and ultimately led to his dismissal and removal to Munich, where he was appointed curator of the Bavarian State Painting Collections. He brought with him in his luggage a number of important works of art that he had not been able to acquire for the National Gallery in Berlin. The Neue Pinakothek was now to profit from these; and further acquisitions were envisaged. In Munich, however, von Tschudi encountered the same difficulties as in Berlin, and only his premature death saved him from another dismissal. During his brief time in Munich, he was able to acquire only a few works: *Deployment of Artillery* by Géricault, *Wier near Optevoz* by Courbet, and a number of paintings by members of the Munich School

9

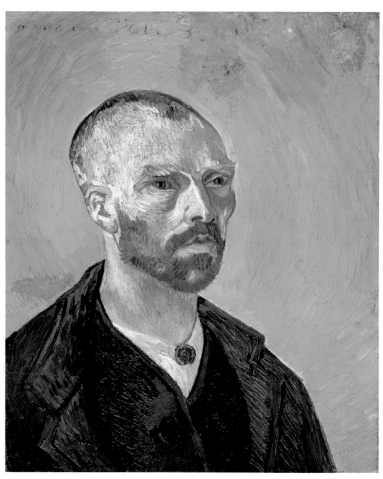

Vincent van Gogh, Self-Portrait, 1888, canvas, 62 x 52 cm.
Fogg Art Museum, Harvard University Art Museums, Cambridge, Massachusetts;
bequest of Collection of Maurice Wertheim

including Leibl, Schuch, Trübner, among others.

With the aid of private donations, Tschudi's assistant Heinz Braune undertook the acquisition of the works foreseen for the Neue Pinakothek, as well as additional pieces for a "Foundation to the Enduring Memory of Hugo von Tschudi." He was so successful in his efforts that in 1912 he applied to the relevant ministry for permission to accept, on behalf of the Bavarian State Painting Collections, the works that had already been given to Tschudi, those that had been reserved and for which Tschudi had sought donors, and, finally, new donations from Tschudi's friends and admirers. Among the most important donors were Eduard Arnhold and Robert von Mendelssohn in Berlin. The process dragged on for some time, but by 1914 no fewer than forty-four paintings, nine sculptures, and twenty-two drawings had been acquired, including works by Courbet, Daumier, Pissarro, Cézanne, Renoir, van Gogh, Gauguin, Matisse, Rodin, Maillol, and other modern artists. The ministry approved the donation, but decided that the works should go first into storage, since "the artistic merit of certain of them was still disputed." It was an affront to Heinz Braune and above all to the donors, but Braune managed to circumvent the instructions of the ministry and make the donated works accessible to the public in the context of the Neue Pinakothek.

One of the most spectacular paintings that Tschudi had proposed for acquisition was van Gogh's *Self-Portrait* of 1888. In 1919, it was purchased from Tschudi's widow for the Neue Pinakothek, only to be seized in 1938 as an example of "degenerate art" and auctioned off in Lucerne in 1939. The story of this acquisition is typical of the history and politics of modern art: the work stood outside the publicly recognized canon of art and had been painted not by an academician or by a famous artist such as Bouguereau, Lenbach, or Albert von Keller, but by a virtually unknown painter. As a result, it was initially only the sensitive few – artists, persons of letters, art historians, private collectors, and art dealers – who showed any understanding for a work of this kind, and who were able to convey some impression of its value to others. At the same time, it is a remarkable and telling fact that in the decades around 1900, there was a greater understanding for this art in Germany than in other countries.

Christian Lenz

Paul Cézanne, The Railway Cutting, c. 1870, canvas, 80 x 129 cm (8646) (see pg. 113)

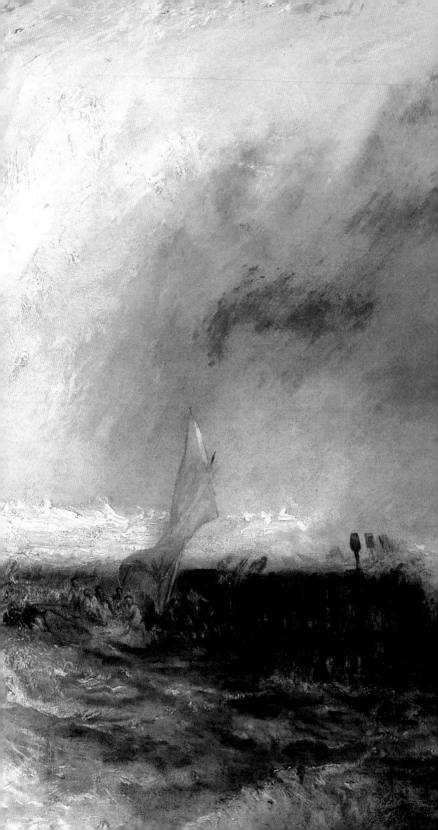

International Art around 1800

Exhibited at the beginning of the route through the gallery are prominent examples of European painting from around 1800. The special characteristics of much of this art are the quest for a new veracity, an unpretentiousness in human affairs, and a renewed interest in nature. Winckelmann's expression of "noble simplicity and quiet grandeur" and his vision of a free, democratic way of life, as in ancient Athens – the basis of the sublime beauty and harmony of the art of classical antiquity – were influential in this respect, as were the liberal currents of the times which found their cataclysmic climax in the French Revolution. The repercussions of this revolt led, in turn, led to the development of a new, fundamentally bourgeois society. However, the horrors and confusion caused by the French Revolution shattered public trust in the power of reason and revealed a hitherto unsuspected dimension of irrationalism in the human soul, to which artists were to lend expression. Thus, around 1800, two phenomena manifested themselves, both of which pointed the way to modernism. Seen in conjunction with each other, they form something of a polarity: on the one hand, there is the lucidity of reason, which has its counterpart in God's sensible natural order; on the other hand, there is a world that is fantastic and removed from the rational grasp of man.

In landscape painting, themes from the familiar natural world of northern Europe begin to replace the classical, ideal images of Italy, which had long enjoyed canonical status through the work of the two great masters of landscape painting in 17th-century Rome: Nicolas Poussin and Claude Lorrain. In portraiture, a comparable change manifested itself. The subject was now presented in a natural manner, for the most part devoid of rank and tokens of status and avoiding all trace of sublimation. This quest for simplicity and honesty was paralleled by a new fondness for depicting the figures in a natural setting.

English Landscape Painting

In late 18th-century England, stimulated by the founding of the Royal Academy of Arts in London in 1768 under the presidency of Joshua Reynolds, an independent school began to develop. This, too, had a pioneering influence on continental European painting, especially landscape, portraiture, and, before long, genre painting, which had been extremely popular since Hogarth's time. The idealized classical landscape with its characteristic elements – a large tree set on one side in the foreground (in many cases with a meandering

river that articulates the breadth and depth of the picture) and warm golden tones in the foreground that become increasingly cool towards the background – began to yield to genuinely northern subjects: moors, streams, marshy ponds, and thickets, all of which are based on reality, at least in their pictorial composition. This new veristic impression of nature is accentuated by the unmistakable, subdued quality of English light, overlaid with a veil of almost vegetal dampness.

The landscapes by **Richard Wilson** (*b*. Penegoes, Montgomeryshire, 1714; *d*. Colommendy, Denbighshire, 1782) provide a good illustration of this shift of emphasis in landscape painting. As Theodor Fontane wrote, Wilson is "not the father of English landscape painting; but he is the father of landscape painting in England." From 1750 to 1755 he worked in Italy, initially in Venice, then for four years in Rome, and, finally, for a few months in Naples. After his return to Britain, he frequently painted idyllic landscapes such as the *Southern Coastal Landscape at Evening*, in which he evokes an untroubled Arcadian mood. Even in his unmistakably English landscapes, such as *View across the Thames at Kew Gardens to Syon House*, his artistic interest lies not in descriptive veduta painting, but in conveying an impression of the sheer breadth of a scene and the unresolved atmosphere of an afternoon in early autumn, in which forms and color appear to dematerialize in the light.

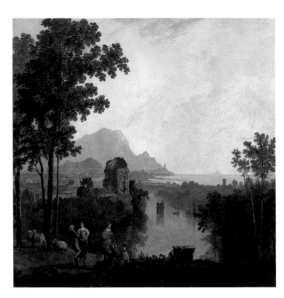

Richard Wilson, Southern Coastal Landscape at Evening, c. 1770–80, canvas, 139.6 x 184.3 cm (HuW 36)

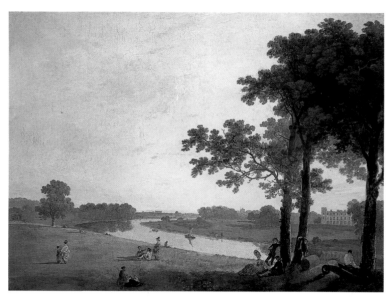

Richard Wilson, View across the Thames at Kew Gardens to Syon House, *c.1760–70, canvas, 104 x 138.5 cm (14559)*

Unlike Wilson, **Thomas Gains-borough** (*b.* Sudbury, Suffolk, 1727; *d.* London, 1788) never traveled abroad. He taught himself to paint by, among other things, making copies of the works of 17th-century Dutch and Flemish masters. His *Landscape with Shepherd, Sheep and Cattle*, painted in the autumn of 1783, was inspired by a journey he made to the Lake District. The scene is set in a small hollow in a hilly heath-like landscape, where a dammed stream provides water for several animals and a herdsman finds shelter from the wind. The trees and the tips of the mountains in the distance – a stylized echo of

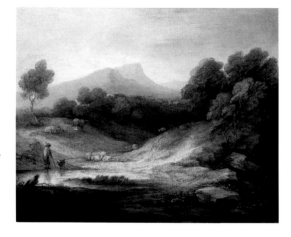

Thomas Gainsborough, Landscape with Shepherd, Sheep and Cattle, *1783, canvas, 120.7 x 148 cm (BGM 4)*

John Constable, Dedham Vale Seen from East Bergholt, *c.1825, canvas, 45.6 x 55.1 cm (FV 5)*

the Langdale Pikes – seem to lean protectively over the scene. The individual forms in the painting are subordinated to an overall formal rhythm. Together with the gray atmosphere pervading the picture, captured in dark tones that seem saturated with moisture, the naturalistic composition conveys the unmistakable impression of an inhospitable, wild, and solitary region.

John Constable (*b*. East Bergholt, 1776; *d*. London, 1837) never traveled outside England. Although he studied at the Royal Academy, he was largely self-taught. His lifelong efforts at capturing the full range of nature in his pictures reveal the influence of 17th-century Dutch landscape painting on him.

Dedham Vale Seen from East Bergholt presents a broad, hilly, cultivated landscape interspersed with bushes and a number of trees. The mood of the scene is set by the sky with its heavy clouds. Constable depicts what is, in conventional terms, an unimportant detail of the landscape from his native Suffolk (on the flat east coast of England). The special attraction of this oil sketch is the spontaneity and candour of the view, which forgoes common compositional and scenic effects without abandoning its special vision of the world as a harmonious cosmos. In this context, the church tower of Dedham, which is a recurring feature in Constable's landscapes, becomes a symbol of God. In view of the different treatments of the foreground, background, and sky,

Constable's authorship of this picture has been questioned. What is likely, however, is that he worked on the landscape at different periods of his creative life, or that he differentiated his treatment of the various areas, as he later did, on many occasions, in his mature work. With his large-scale, elaborately worked landscapes, Constable attracted great attention at the 1824 Salon in Paris and became an influential figure for the painters of the Barbizon School and, later, the Impressionists.

In the works of **Joseph Mallord William Turner** (*b*. London, 1775; *d*. Chelsea, 1851), English Romantic landscape painting attained a pictorial language that may be seen to anticipate Impressionism. Especially in his late pictures, which are reductive whirls of color, Turner seems less intent on depicting actual landscapes than on expressing emotional moods materialized in nature. Turner's depiction of conflicting elemental forces reflect a peculiar alternation between concentration and dissolution in his use of color and light. His painting *Ostend*, exhibited in 1844 at the Royal Academy, London, at first sight appears to be a composition of pure color. Only on closer inspection does a dramatic scene reveal itself. Beneath an endless sky, overcast with scudding clouds, two tiny sailboats struggle on a storm-tossed sea to reach the safety of the harbor mole. With gestures of fear, a number of figures on the mole follow this battle between man and the elements. In this work, man is portrayed as a creature at the mercy of nature, whether vehemently resisting it or accepting it with equanimity as his fate.

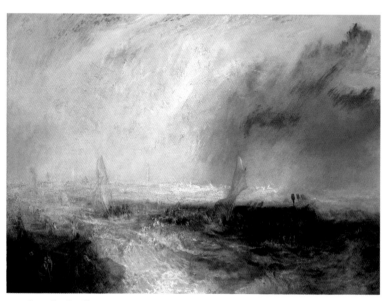

Joseph Mallord William Turner, Ostend, *1844, canvas, 91.8 x 122.3 cm (14435)*

International Portraiture

The portraiture of **Thomas Gainsborough** (*b*. Sudbury, Suffolk, 1727; *d*. London, 1788) reveals a fusion of naturalistic elements with atmospheric values that serve to heighten the emotional expression of his subjects. This may be seen in his likeness of *Mrs. Thomas Hibbert*, whose elegant figure is set against a lofty backdrop of bushes and trees. In spite of the fashionable artificiality of her silvery shimmering silks, her elaborate head of curls, extravagant feathered hat, and shawl, in all its gossamer translucence, the foliage – depicted as if caught in a sudden gust of wind – lends the elegant lady a note of natural simplicity. This mutual heightening of nature and artificiality – which is faintly reminiscenct of courtly Rococo shepherdesses – is a decisive element in the fascination radiated by

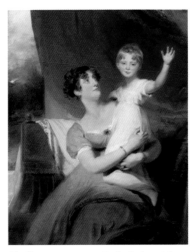

Sir Thomas Lawrence, Lady Ordre with Her Daughter Anne, *1810–12, canvas, 141.5 x 111.6 cm (HuW 16)*

the subject of this picture. Gainsborough was one of the founding members of the Royal Academy of Arts. After settling in London, he became the most sought-after society portraitist of his day – alongside Sir Joshua Reynolds – because of the natural settings in which he portrayed his subjects.

In his portrait of *Lady Ordre with Her Daughter Anne*, **Sir Thomas Lawrence** (*b*. Bristol, 1769; *d*. London, 1830) continued the tradition of fine portraiture practiced by Sir Joshua Reynolds. (Lawrence also owed a great debt to Sir Anthony van Dyck, who became court painter to King Charles I in London in 1632.) The monumental portrayal of mother and daughter, viewed slightly from below, with its formal setting in front of a curtain and elevated presentation of the child reveal a concept of portrait painting that is wholly Baroque. The

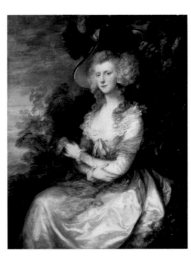

Thomas Gainsborough, Mrs. Thomas Hibbert, *1786, canvas, 127 x 101.5 cm (FV 4)*

shimmering quality of the materials and the cool smooth incarnate are also reminiscent of van Dyck, although the broad, flowing brushwork, warm coloration, and natural sense of intimacy between mother and child are very modern for the time. Lawrence, an artistic prodigy and autodidact, enjoyed international acclaim as a society portraitist, especially after the Congress of Vienna at which he presented portraits of the leading figures of Europe to a commission sent by the Prince Regent in England.

Jacques Louis David (*b.* Paris, 1748; *d.* Brussels, 1825) was the most famous French painter of the Revolution and the First Empire. He is best known for his depictions of events that took place during the Roman republic, paintings that should be seen as a programmatic tribute to a new political era. His portrait of the *Marquise de Sorcy de Thélusson*, who was the daughter of a Geneva banker and married to a French nobleman, is one of David's most remarkable likenesses. Wearing a simple white dress and equally modest shawl, the young woman is seated before a neutral wall, her eyes turned to the observer. The unpretentious naturalness of her attire is reflected in the clear lines and the strict compositional arrangement, which focuses atten-

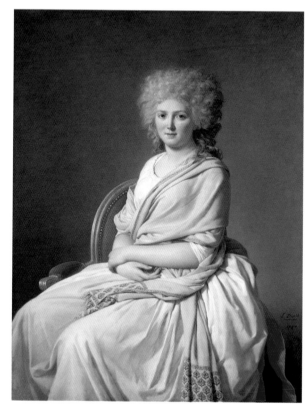

Jacques Louis David, Marquise de Sorcy de Thélusson, *1790, canvas, 129 x 97 cm* (HuW 21)

tion on the youthful appearance of the subject by omitting all superfluous details. The effect made by the figure, bathed in bright light, is not the outcome of a subtle pose, precious accessories or the refinement of the coloration. The marquise exerts a direct fascination through her laconic elegance, her compact, three-dimensional presence, which, in the lucid purity of the coloration, is reminiscent of the clarity and naturalness of Classical sculpture.

The sculptures of **Antonio Canova** (*b*. Possagno, 1757; *d*. Venice, 1822) mark a final renunciation of Baroque emotions in favour of calm restraint and dignity. A characteristic feature of the work of this leading representative of Neoclassicism is the way he stylizes antiquity by working from a concept of "nature refined to beauty," in which contemporary elements are included. He created numerous works for Napoleon and his family; and when the 18-year-old Bavarian Crown Prince Ludwig saw a sculpture by Canova in Venice, it was a crucial experience in his lifelong enthusiasm for art. The model for the statue of *Paris* was made in 1807. Canova then proceeded to work it in marble for various commissions, including one from Ludwig in 1816. Paris, the beautiful son of King Priam of Troy, had been abandoned as a child and brought up by shepherds. Called upon to decide which goddess – Hera, Athena, and Aphrodite – was the most beautiful, Paris chose Aphrodite and awarded her the apple of Discord. As a reward, he was granted Helen as his wife, which,

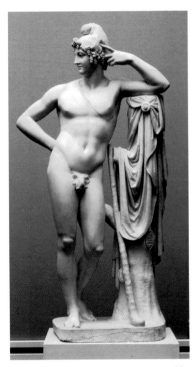

Antonio Canova, Paris, *1807–1816, marble, h. 205 cm (WAF B.4)*

later, sparked the Trojan War. Here Canova depicts Paris with his lips parted in speech, his head propped on his hand in the pose of a thinker, and with a conscious display of hubris, aware of his own beauty. The apple is concealed behind his back.

One of the greatest Spanish painters on the threshold of modernism was **Francisco José de Goya y Lucientes** (*b*. Fuendetodos, Saragossa, 1746; *d*. Bordeaux, 1828). He was a versatile artist, able to express himself with equal facility in both painting and the graphic arts. Goya painted pleasing society portraits as well as satirical character studies, religious paintings, and

a number of outstanding still lifes: In his early years, he painted playfully blithe genre scenes, in which echoes of the Rococo world may still be found (e.g. his designs for the Royal Tapestry Manufactory in Madrid). In his graphic works, which were perhaps his most personal means of pictorial expression, Goya depicted social and political ills – possibly as an attempt to come to terms with his personal obsessions and nightmares.

Don José de Queraltó in the Uniform of a Spanish Army Doctor is an example of Goya's masterly portrait art. In a manner equal to that of Rembrandt and perhaps even of El Greco, the figure is against an unbroken dark background, against which striking facial features and

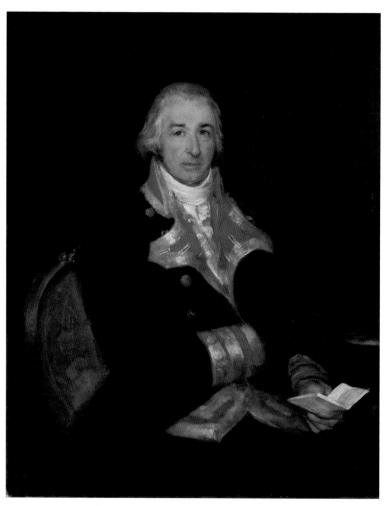

Francisco José de Goya y Lucientes, Don José de Queraltó in the Uniform of a Spanish Army Doctor, *1802, canvas, 101.5 x 76.1 cm (9334)*

his red and silver tunic are illuminated. An impressive aspect of the painting is the artistic mastery of the brushwork, which is elaborated in intense, finely worked detail in the portrayal of the face. In the areas of the uniform, however, the technique confines itself to a free, abbreviated description of the forms. The subject thus acquires a certain vitality, as if momentarily interrupted in his concentration on a certain task. Queraltó, portrayed here as a doctor with the rank of a general, was a surgeon and held a number of high positions in the public health service. Goya allegedly gave him this painting in gratitude for his medical help.

Goya's *Plucked Turkey* is an unusual version of the kitchen still life, a genre borrowed from traditional Dutch and Spanish painting. In contrast to the earlier forms of this genre – aesthetic compositions of everyday objects or luxury articles, in which attention was paid to a variety of surface attractions – in this still life, a stiff fowl is brutally stretched on the diagonal, in an artificial and unstable arrangement across the entire picture, and propped up by a pan of sardines. Naked, illuminated by bright, artificial light, and exposed to display against the diffuse background, the turkey becomes a disturbing, symbolic, indeed tortured expression of suffering.

The portrait of *Heinrich XIII Count Reuss from the Elder Branch of the Family* is a character study by the Swiss-born painter **Anton Graff** (*b*. Winterthur, 1736; *d*. Dresden, 1813), who was a professor of portraiture in Dresden. Depicted as a young man Reuss has a sceptical, inquisitive expression and a

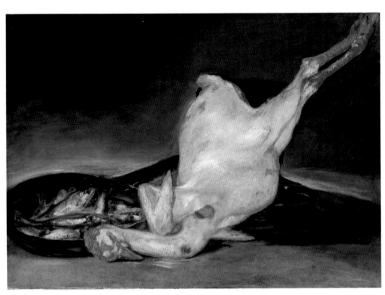

Francisco José de Goya y Lucientes, Plucked Turkey, *1810–23, canvas, 44.8 x 62.4 cm (8575)*

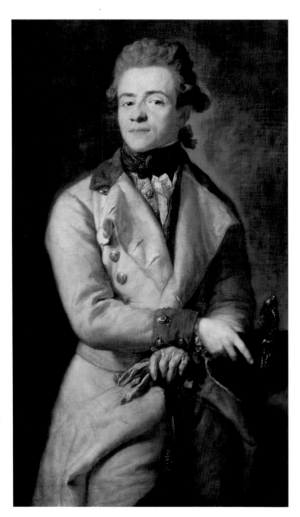

Anton Graff,
Heinrich XIII Count
Reuss from the
Elder Branch of the
Family, *1775,*
canvas,
112.6 x 84 cm
(9954)

searching, appraising look in his eyes, which seem to follow the observer. His casually opened uniform jacket (that of a field officer in an Austrian infantry regiment) appears to be of almost secondary importance, and his powdered Rococo wig no more than a jaunty masquerade. The true intention of the portrait, which avoids all elaborate trimmings and any idealization of the subject – Reuss's shoulders are narrow and sloping – lies in the simplicity of the pictorial means and the restrained color, mostly warm brown tones. With realistic portraits of this kind, in which the spirit of the Enlightenment may be discerned, as well as the dawn of a century that was to witness the rise of the bourgeoisie, Graff, like Tischbein, defined the nature of German portraiture in the late 18th century.

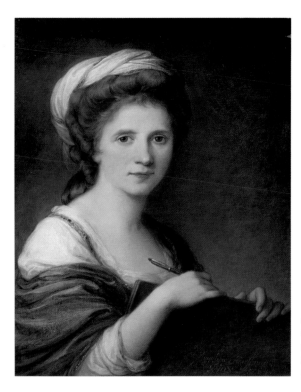

Angelika Kauffmann, Self-Portrait, 1784, canvas, 64.8 x 50.7 cm (1056)

A different aspect of portraiture may be seen in the small *Self-Portrait* by **Angelika Kauffmann** (*b*. Chur, 1741; *d*. Rome, 1807). Born in the Swiss canton of Grisons, Kauffmann worked for a time in Italy and then London, where she became a member of the Academy and received numerous commissions from the aristocracy. In 1782, she finally settled in Rome, in the house formerly occupied by Anton Raphael Mengs. Well known for her engaging personality, intellect, and charm, she was a friend of Goethe and Herder. In this half-length self-portrait, Kauffmann addresses the viewer, holding a pencil and drawing board in her hands, rather like a muse of painting. This classical, academic pose corresponds to the timeless, idealized youthfulness of her appearance and the ancient style of the turban drawn over her softly falling locks of hair. Ironically, she was 43 years old when she painted this picture.

History and Genre Painting

Drawing its inspiration from 17th-century Dutch models, genre painting became a popular form of art in England towards the end of the 18th century. The works of the Scottish painter Sir David Wilkie (*b*. Cults, Fifeshire, 1785; *d*. at sea, 1841), with their depictions of the middle classes and farming life, were greatly in demand. Working in

the tradition of William Hogarth, Wilkie presents a detailed, witty narrative and satirical picture of society in his *Reading of the Will*. The character studies are outstanding, revealing the reactions of various members of the family as the will is read. The picture, which was painted on wood according to its commissioner King Maximilian I Joseph of Bavaria, has a wonderful patina in the manner of the Old Masters. The king hung it in his *chambre au coucher* where *tout le monde admire le tableau*. Wilkie traveled extensively during the course of his life, visiting France, Germany, Italy, and Spain. He died at sea while returning from the Orient, where he had received a commission to paint a portrait of Pasha Muhammed Ali. Wilkie enjoyed considerable renown as a portraitist. His funeral occasioned Turner to paint the famous picture *Peace – Burial at Sea* in 1842 (Tate Gallery, London).

Around 1800, history painting was less common in England than portraiture, landscape and genre painting, but a special interest in literary subjects led to the creation of a number of remarkable works of a new kind. Henry Fuseli, born Johann Heinrich Füssli (*b.* Zurich, 1741; *d.* London, 1825), was a leading exponent of paintings inspired by works of literature. Initially, he studied theology, but his career was brought to an end by his outspoken political views. Influenced by the Swiss historian and critic Johann Jacob Bodmer, Fuseli showed an early interest in the works of Homer, Dante, Shakespeare, Milton, and the *Nibelungenlied*, all of which prompted him to write his own poems. Here lie the roots of his love of all things wonderful and fantastic in poetry and his mingling of literature and painting. At the advice of Reynolds in London in 1768, he decided to devote himself to painting, having

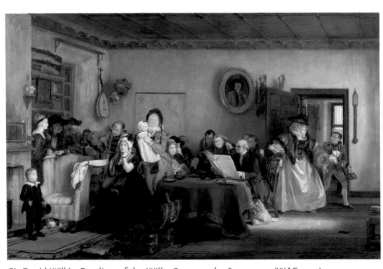

Sir David Wilkie, Reading of the Will, *1820, panel, 76 x 115 cm (WAF 1194)*

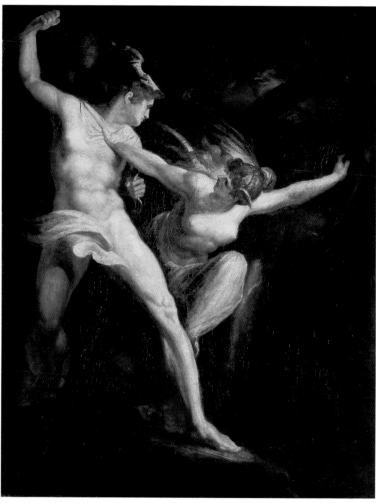

Henry Fuseli, Satan and Death, Separated by Sin, *1792–1802, canvas, 91.3 x 71.1 cm (9494)*

hitherto produced only drawings. He trained himself, in part by studying the works of Michelangelo and Luca Signorelli, and made a close analysis of the writings of Winckelmann and Rousseau. The painting *Satan and Death, Separated by Sin* is typical of Fuseli's love of demonic, fantastic, and symbolic subjects, with which he enjoyed great success in London. The theme is taken from Milton's epic *Paradise Lost*, which was first published in 1667, and which Bodmer had translated into German. The poem inspired further paintings by Fuseli. The main figure is depicted in a pose that is both heroic and manneristic, and at the same time expressive of existential isolation. Together with William Blake, Fuseli is regarded as a forerunner of a literary line of Romanticism in England.

German Romanticism

"... everything is pressing towards the landscape, seeking something specific in the unspecific, yet not knowing how to begin.... Does a work of art not come about precisely at that moment when I sense a distinct link with the universe?"
(Philipp Otto Runge)

Emotional sensibility and the world of the creative individual are key factors in the artistic expression of the Romantic movement. In some respects, therefore, Romanticism represents a counterposition to the belief in reason which was a distinguishing feature of the age of Enlightenment in Europe. On a practical level, it was a reaction to the authority of the art academies and the control they exercised over the world of painting, and to the austerity of the fashionable formal language of Neoclassicism. Romanticism, which had its origins in the disciplines of literature and philosophy, rediscovered the Middle Ages and Nordic myth as a rich source of subject matter. Also influential in this respect were contemporary national aspirations, which, in the context of Napoleon's bid for hegemony in Europe, promised a means of overcoming the particularism of the German states. On the threshold of modernism, the human conception of the world was fast disintegrating into a number of contradictory fragments. Broadly speaking, the complex Romantic move-ment may be regarded as an attempt to regain a single, harmonious world view. The healing powers of harmony were sought in transcendentalism, nature, and a movement towards religious renewal. In practical terms, these ideals were also pursued by like-minded persons in societies of artists, where the individual could find refuge from the creative solitude of the modern world. At this point, mention should also be made of man's increasing alienation from nature as a result of the triumphal advance of technology – a phenomenon that became an important subject in art of the time. The artistic centres of this new Romantic awakening in Germany (around 1800) were Dresden and Berlin in the Protestant north and Düsseldorf and Munich in the Roman Catholic south. Dresden, the Baroque seat of residence of the rulers of Saxony, was renowned for its outstanding Electoral painting gallery. Since the founding of the Academy of Arts in 1764, the city had become a centre of artistic training, and it soon attracted many of the leading minds of the Romantic movement, including the Schlegel brothers, Tiek, Novalis and Wackenroder.

Caspar David Friedrich (*b.* Greifswald, 1774; *d.* Dresden, 1840) came to Dresden in 1798, after studying at the most famous academy in northern Europe at that time –

Copenhagen – where Runge, Dahl, and Kersting were soon to follow. Friedrich studied the Old Masters in the gallery in Dresden and went on extensive hikes to explore the surrounding countryside. He also visited the sandstone hills along the Elbe, the island of Rügen in the Baltic, and later the Harz Mountains, the Riesengebirge, and Bohemia. Everywhere he made numerous sketches of plants, trees, mountains, and rock and cloud formations, which served him throughout his life as study material for the composition of individual details and complete landscape scenes. Impressions of this kind, collected, not in Italy, but in his native countryside, were condensed by Friedrich into works in which the stylized depiction of nature is symbolically heightened. As mystical descriptions of the almighty powers of God, Friedrich's paintings are similar to devotional pictures, as in

the case of the Tetschen Altar in the Painting Gallery in Dresden. Friedrich associated with leading literary figures of the Romantic movement, such as Kleist and Novalis, and was friends with Carus, Dahl, Runge, and Kersting in Dresden. Before long, Friedrich's art and pictorial language, which were expressions of subjective emotions and a personal sense of religion independent of Church authority, were no longer understood and fell into obscurity. It was not until 1906, when Hugo von Tschudi presented thirty-six of Friedrich's pictures at the German Centennial Exhibition, that this great individualist was rediscovered. Since then, the painter has been regarded as the leading representative of German Romanticism.

Summer is one of the early depictions of the seasons Friedrich painted in which the cycle of nature is related to the life of man. The

Caspar David Friedrich, Summer, 1807, canvas, 71.4 x 103.6 cm (9702)

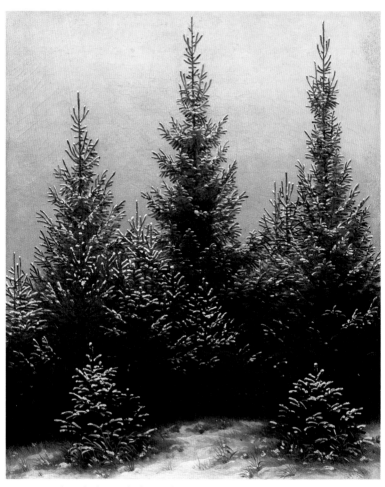

Caspar David Friedrich, Fir Thicket in the Snow, *c.1828, canvas, 30 x 24 cm (ESK1)*

mate to this picture, *Winter*, was destroyed in the fire in the Munich Crystal Palace in 1931. It depicts the ruins of a Gothic church in the snow and a passing monk, bent with age. It appears to be a portrayal of approaching death. The lovely summer landscape, in contrast, is enclosed by gently rolling hills. In the foreground is an arbor of trees with a pair of scantily dressed lovers, in the style of classical antiquity, and two turtle doves. The arbor is surrounded by sunflowers, lilies,

and roses. It is a picture of fullness and fulfilment. The broad, meandering river, however, confines this earthly paradise, making it a transient segment of man's journey through life, which, like the landscape stretching into the distant blue mountains, ultimately leads through death to the omnipotence of God.

Fir Thicket in the Snow, painted some twenty years later, is a miniature representation of a group of trees in winter. However, the strict,

rhythmic arrangement of their tips rising above the thicket in hierarchical symmetry, and the bright snow radiating from their dark branches raise this small, unpretentious painting of nature far beyond the level of a mere study. The concentration and exclusiveness of the description elevates this depiction of nature to an almost absolute level and lends it a kind of sacred monumentality.

The *Riesengebirge Landscape with Rising Mist* is a further example of Friedrich's symbolic distillation of a real scene into a universal landscape and religious metaphor. Devoid of human beings, the picture becomes an image of the finite within the infinite, even though the painting originally contained a small figure next to the withered tree. Friedrich's unusual composition and formal reductivism – in the planar quality of the three-dimensional forms, perspective,

and color – were the subject of great debate in his day. Friedrich's advice to an artist was: "Close your physical eye, that you may see your picture with your spiritual eye first. Then bring to light what you have seen in the dark, so that it may have an effect on others from the outside inwards." Friedrich went hiking in the Riesengebirge on only one occasion, in 1810, together with Georg Friedrich Kersting. However, during the course of his later life he used the sketches and studies he made at that time to make paintings of various landscapes of the Riesengebirge.

In his *Morning after a Stormy Night*, **Johann Christian Clausen Dahl** (*b*. Bergen, 1788; *d*. Dresden, 1857) depicts nature as a primal force that poses a threat to human life. The waves of the sea, slowly coming to rest, beat in showers of spray against a precipitous rocky coast,

Caspar David Friedrich, Riesengebirge Landscape with Rising Mist, *c.1819–20, canvas, 54.9 x 70.3 cm (8858)*

Johann Christian Clausen Dahl, Morning after a Stormy Night, *1819, canvas, 74.5 x 105.6 cm (14631)*

as dark storm clouds recede. A capsized sailing boat can be seen beyond a mighty rock. Seated in the foreground, his head on his knees, is an elegantly attired man, who is watched by a dog. They are evidently the only survivors of a shipwreck. In their utter exposure to the malevolent elements, these two tiny figures, illuminated as if by the beam of a searchlight, are an expression of hopeless isolation and despair. The Norwegian painter Dahl lived from 1818 in Dresden and, after a journey to Italy in 1823, moved into Caspar David Friedrich's house there.

Rest on the Flight into Egypt by **Philipp Otto Runge** (*b.* Wolgast, 1777; *d.* Hamburg, 1810) is a preliminary sketch for a picture with the same title that is now in the Kunsthalle in Hamburg. In the sketch, Runge dispenses with all symbolic heightening and styliza-

Philipp Otto Runge, Rest on the Flight into Egypt, *c.1801, canvas, 22.9 x 31.8 cm (15437)*

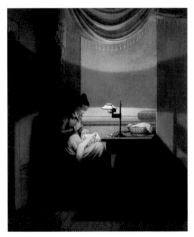

Georg Friedrich Kersting, Young Woman Sewing by the Light of a Lamp, *1828, canvas, 40.3 x 34.2 cm (14603)*

strokes in subdued, earthy colors lend expression to Runge's idea of ubiquitous presence of God in nature. After completing his studies, the painter lived in Copenhagen and Dresden and spent a great deal of time in Hamburg. He died at an early age.

Beginning in 1818, **Georg Friedrich Kersting** (*b.* Güstrow, 1785; *d.* Meissen, 1847) belonged to the circle of Romantic artists working in Dresden. His small painting *Young Woman Sewing by the Light of a Lamp* seems to bridge the gap between Romanticism and the warm-hearted sentiment of Biedermeier. At the same time, the plain, austere simplicity of the interior, composed of succinct areas of color, and the way in which the view is focused on the activity of the woman and her sewing utensils — beside which only a Bible has any

tion of the theme. Instead, he shows a small family at rest, sheltered beneath the overhanging vegetation. Even in this study, the interweaving plants and figures, and their articulation in broad brush-

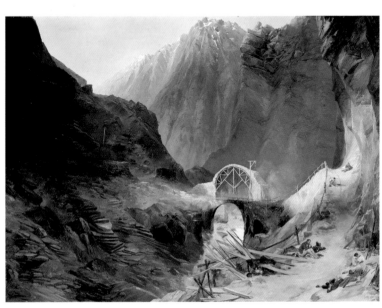

Carl Blechen, The Building of Devil's Bridge, *c.1830, canvas, 77.6 x 104.5 cm (L.1039)*

weight – transform this scene into a quiet, poetic celebration of domesticity.

Blechen and Schinkel were two outstanding artistic personalities in Berlin during the period when Romanticism began to emerge. **Carl Blechen** (*b*. Cottbus, 1798; *d*. Berlin, 1840) began his career as a bank clerk in Berlin, but his main leisure activity was drawing. Before long, he was to make it his profession, initially studying landscape painting at the Academy in Berlin. His visit to Dresden in 1823, where he met Dahl and probably Friedrich, too, had a formative influence on him and led to the development of his personal approach to nature: a combination of visionary Romanticism with elements that anticipate Realism. In *The Building of Devil's Bridge*, for example, nature is no longer something exclusively alien or set apart, as it is in Friedrich's transcendental work, or in Dahl's depiction of untamed elemental powers. In Blechen's painting, despite its forbidding inaccessibility and ruggedness, nature is gradually being overcome by man. This remains true, even where the working process is superbly depicted. The bridge emerges as a fragile work of art and the labour needed for its construction is shown with a vast difference in scale – from the small, exhausted figures resting by the side of the road to the noble, picture-filling mass of mountains towering up on all sides. In 1829, on his return from Rome, Blechen made a number of sketches of the "Devil's Bridge," as it is known, on the St. Gotthard Pass.

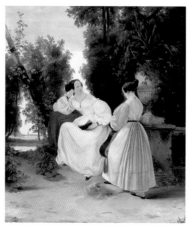

Carl Blechen, Two Ladies in a Park, *c.1827, canvas, 39 x 33 cm (9875)*

In contrast to this, the little painting *Two Ladies in a Park* depicts an intimate subject that is unconventional for the random nature of the detail shown. Although at this stage of his career, Blechen had not yet been to Italy, his handling of color and light already contained a hint of the later influence of the South. The simple, white, finely painted apparel of the two women is semi-luminous and reflective in contrast to the amorphous darkness of the park.

Karl Friedrich Schinkel (*b*. Neuruppin, 1781; *d*. Berlin, 1841), another major artistic figure in Berlin around 1800, is regarded as a leading architect of German Neoclassicism. His *oeuvre* includes a distinctly Romantic phase inspired by the patriotic ideas in circulation at the time of the German Wars of Liberation against Napoleon. His vision of a renewal of the Church, emphatically expressed in his painting *Cathedral Towering over a Town*, belongs to this phase of his development. The painting is dominated

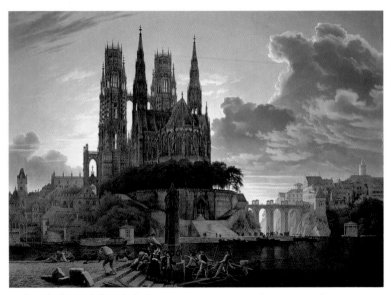

Karl Friedrich Schinkel, Cathedral Towering over a Town, *after 1813 (copy by K. E. Biermann), canvas, 93.8 x 125.7 cm (13422)*

by a distinctly neo-Gothic style church, which at that time was regarded as an expression of "Germanism." The church is elevated above the small-scale structure of the town and thus may be seen as a symbol of common endeavor expressed through art, or, as Schinkel formulated it, "the central point of all higher artistic activities of the country, in which all artists of excellence" would be united ("Memorandum on the Cathedral of Freedom," 1814). The somewhat smaller version of this work – painted by Schinkel himself and formerly in the National Gallery in Berlin – was destroyed by the fire in the Munich Crystal Palace in 1931. According to Börsch-Supan, the Munich version is a copy of extremely high quality by Schinkel's pupil K. E. Biermann (1803–1892).

At first, Munich was merely a stopping place for leading figures

of the Romantic movement such as Clemens and Bettina Brentano, Ludwig Tieck, the Schlegel brothers, and Boisserée. In fact, Romantic painting only began to have an impact in Munich in the 1820s, in the circle of Cornelius and his school.

Like Schinkel, **Leo von Klenze** (*b*. Schleden, Hanover, 1784; *d*. Munich, 1864) initially studied in Berlin, where he was a pupil of Gilly, before going on to Paris and Italy to continue his education. In his position as court building director to Ludwig I, to which he was appointed in 1819, von Klenze gave Munich its Neoclassical character. The Glypthothek, which he built between 1816 and 1830, was the first public museum for the art of classical antiquity in Germany, and his Alte Pinakothek (1826–1836), became the model building type for modern galleries of art. In the

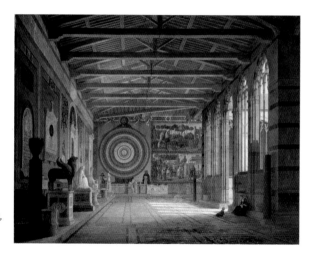

Leo von Klenze,
Camposanto in
Pisa, *1858, canvas,*
103 x 130.5 cm
(13078)

course of his numerous journeys to Italy and Greece undertaken on behalf of the king, Klenze drew many sketches and studies from nature, which he reworked into his oil paintings. The *Camposanto in Pisa*, painted towards the end of his life, shows that the architect's interest was not confined to the art of classical antiquity and the Italian Renaissance, but included the simple, monumental forms of the Middle Ages, and the clear, boldly colored decorative frescoes of that period, which he captures here on a grand scale. The pencil sketch on which this painting is based is in the Bavarian State Library in Munich.

Johann Georg von Dillis (*b*. Grüngiebing, Wasserburg, 1759; *d*. Munich, 1841) began his studies at the Academy for Drawing in Munich in 1782, the year in which he was ordained as a priest. In 1786, he was granted a dispensation from his religious duties and began to work as a tutor for drawing in the houses of the nobility in Munich. With his appointment as director of the Court Garden Gallery in 1790,

Johann Georg von Dillis,
Triva Palace, *1797, panel,*
19 x 26.3 cm (9392)

he began a new career as custodian and administrator of the freehand drawing and picture collections of the ruling house of Bavaria. In 1805, King Maximilian I Joseph appointed Dillis as artistic adviser to his son, Crown Prince Ludwig, who had revealed a headstrong nature in the acquisition of works of art. In 1822, he was made "Central Director of Galleries" in which capacity he published the first catalogue of paintings of the Royal (Alte) Pinakothek in 1838. The *Triva Palace* is a depiction of an urban villa in Munich which stood at the beginning of what is today the Briennerstrasse, behind the church of the Theatine order (St. Cajetan's). The villa is not in the form of an architectural veduta, with prominence given to its facade. Rather, it is depicted as if in passing, partially masked by a group of trees, in the shadow of which stands a woman wearing a straw hat. As a result of the unusual interpretation of the subject, the attention paid to the lighting conditions specific to the time of day, and the easy, sketch-like brushwork, this small view may be seen to anticipate the later plein air paintings of Impressionism.

Isar Landscape near Munich by **Wilhelm von Kobell** (*b.* Mannheim, 1766; *d.* Munich, 1853) is still in the Dutch tradition of broad, flat panoramic landscape painting. The even quality of the lighting, however, in which every detail is revealed with the utmost clarity – from the finely painted grass in the foreground, to the broad expanse of the Isar, to the striking towers of the city and the distant silhouette of the Alps – lends the landscape an ideal character. A flute-playing boy leading horses to water in the foreground transforms what is a specific detail

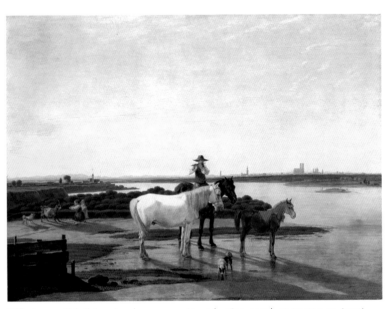

Wilhelm von Kobell, Isar Landscape near Munich, *1819, panel, 40.5 x 53.5 cm (9213)*

Ernst Fries, View of Neckargemünd from Kleingemünd near Heidelberg, *1828, canvas, 32 x 40 cm (10132)*

painted from nature (the scene takes place in Oberföhring) into a modest, Biedermeier-like Arcadia. In 1792, Kobell became court painter to Elector Karl Theodor in Munich, where he soon made the acquaintance of Dillis and his circle of friends. Alongside Dillis, Kobell was the most important South German landscape painter of his day.

At an early age, **Ernst Fries** (*b.* Heidelberg, 1801; *d.* Karlsruhe, 1833) came into contact with the circle of Romantics around von Arnim and Brentano in Heidelberg. He initially studied in Rottmann's studio, together with Carl Philipp Fohr, and later learned the technique of oil painting from the English landscape painter Wallis. On two occasions Fries traveled to Italy, and in Rome he belonged to the circle of artists around Josef Anton Koch. In 1831, he became court painter in Baden. Fries's lovely landscapes with their tonal lighting values and lively moods were greatly sought-after internationally as collectors' pieces. The *View of Neckargemünd from Kleingemünd near Heidelberg*

depicts a village nestled in a gently rolling landscape. The scene, bathed in warm sunlight, is idllyic.

Art at the Court of Ludwig I

In the second decade of the 19th century, Crown Prince Ludwig (from 1825, King Ludwig I of Bavaria) was the central figure in the artistic life of Munich. His lifelong passion for collecting works of art, his efforts to give the Bavarian state a modern yet powerful historical form through aesthetically pleasing monuments, and his desire to use as a means of educating the population inevitably made him a key figure for many artists and architects. From the time of his first journey to Italy, when the magnitude of the ruins of Rome made a profound impression on him, he regarded classical antiquity as "the most consummate thing art has created." His second journey to Italy (15 October 1817 – 30 April 1818) paved the way for his interest in Romanticism and Romantic art. In Rome, he made the acquaintance not only of the German Neo-

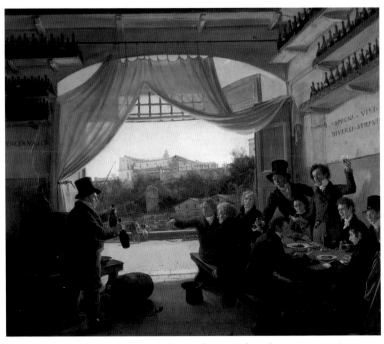

Franz Ludwig Catel, Crown Prince Ludwig in the Spanish Bodega in Rome, *1824, canvas, 63 x 73 cm (WAF 142)*

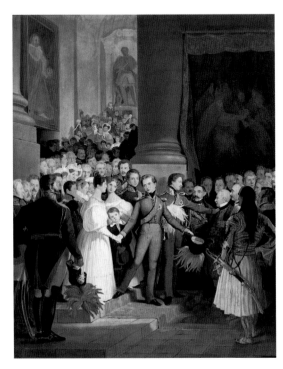

Phillipp Foltz, The Leave-Taking of King Otto of Greece on 6 December 1832, *canvas, 62.3 x 48.5 cm (7935)*

classicists (Hackert, Reinhart, Koch, Thorvaldsen), but of a new kind of patriotically oriented Christian-Romantic art – the art of the Nazarenes. In his enthusiasm for both Classicism and Romanticism, Ludwig is an example, however headstrong, of the way these two contrasting currents might be mingled in the thinking of a single person.

Crown Prince Ludwig in the Spanish Bodega in Rome was commissioned by Ludwig himself in remembrance of his time spent in Rome devoted to the cause of art. The painting is captivating because of its naturalness and serene handling of light. **Franz Ludwig Catel** (*b.* Berlin, 1778; *d.* Rome, 1856) portrays the Crown Prince in 1824, the year of his accession to the throne, surrounded by artists and other close acquaintances who shared his passion for the arts and Italy. Grouped around the table, from left to right, are the Crown Prince; the sculptor Thorvaldsen; the court architect, von Klenze; Count Seinsheim; Johann Martin Wagner (standing with top hat), an agent for art and a painter and sculptor; the painter Philipp Veit; Ludwig's personal physician, Dr Ringseis (standing); the painter Schnorr von Carolsfeld; Catel himself; and Baron Gumppenberg. The Aventine hill can be seen through the open doorway.

The Leave-Taking of King Otto of Greece on 6 December 1832 was depicted by **Philipp Foltz** (*b.* Bingen, 1805; *d.* Munich, 1877) in a painting of remarkably small size. This reflects the intimate context of the act of bidding farewell. Foltz lends the scene, which actually took place in the colonnaded hall of the entrance gateway, a somewhat bourgeois touch. On 8 August 1832, Otto, King Ludwig I's second son, had been elected King of Greece by the national assembly of that country.

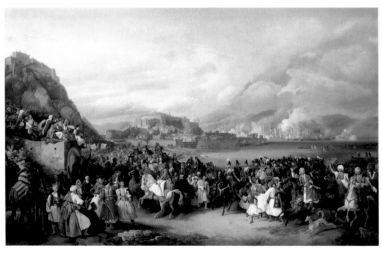

Peter von Hess, Arrival of King Otto of Greece in Nauplia on 6 February 1833, 1835, canvas, 273 x 416 cm (WAF 352)

41

At King Ludwig's request, **Peter von Hess** (*b*. Düsseldorf, 1792; *d*. Munich, 1871) accompanied Otto to Greece to record the events that took place there. Hess painted the *Arrival of King Otto of Greece at Nauplia on 6 February 1833* on a large scale – a size often used for battle scenes. Otto can be seen mounted on a horse in the foreground. The heads of his Bavarian followers and of the reception committee of Greek politicians are based on existing portraits. Ample treatment is given to the alien, oriental character of the young king's new subjects, who welcome him in regal manner with a naval review and gun salute. The mate to this work, the *Reception of King Otto of Greece in Athens on 12 January 1835*, was painted in response to a commission from Otto himself.

Bertel Thorvaldsen (*b*. Copenhagen, 1777; *d*. Copenhagen, 1844) lived from 1797 to 1838 in Rome, where he was influenced by the Neoclassical artist A. J. Carstens. In the general debate on classical antiquity, Thorvaldsen was one of the most consistent exponents of this style, as demonstrated by the calm beauty and supple gracefulness of his figures and by the subject matter he chose, which was strongly influenced by ancient mythology. Thorvaldsen's sculptures were in such great demand internationally that he employed numerous assistants in various studios to execute works for him. Crown Prince Ludwig of Bavaria commissioned him to sculpt the figure of *Adonis* as early as 1808. The execution of the work in marble dragged on until 1832, however. The statue is one of the few pieces, if not the only one, to be executed entirely by Thorvaldsen himself. The figure is distinguished by its unassuming physical expression in the manner of classical antiquity. *Adonis*, sunk in a mood of melancholy, seems transported to another world. The embodiment of youthful beauty, he was loved by Aphrodite and killed by a boar while hunting. At Aphrodite's request, Persephone allowed him to spend six months a year on earth. Like the two god-

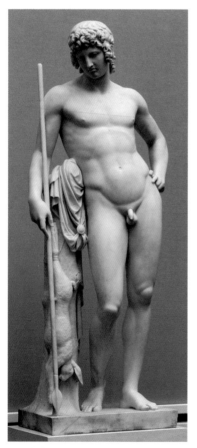

Bertel Thorvaldsen, Adonis, *1808–32, marble, h. 182 cm (WAF B.29)*

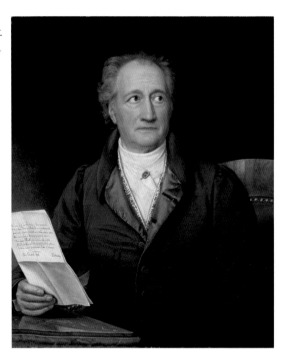

Joseph Karl Stieler,
Portrait of Johann Wolf-
gang von Goethe, *1828,*
canvas, 78.2 x 63.8 cm
(WAF 1048)

desses, he is closely associated
with vegetation and fertility.

Joseph Karl Stieler (*b.* Mainz, 1781;
d. Munich, 1858) was one of the
most active portrait painters in the
service of Ludwig I. In Munich, he is
well known for his "Gallery of Beau-
ties," a series of portraits of the
king's favorite women. Stieler stud-
ied in Vienna and in Paris, where he
was particularly impressed by the
Neo-classical manner of Gérard,
the favourite pupil of David. Stieler
developed a concise, detached por-
trait style. His slightly idealized *Por-
trait of Johann Wolfgang von Goethe*,
which helped to establish the image
of the great German poet, depicts
him, despite his seventy-nine years,
with an erect posture and a fresh
complexion, his eyes focused on
some point in the distance. At the
end of May 1828, Stieler traveled to

Weimar for six weeks at Ludwig's
request to paint this picture. (Since
his youth, the king had revered
Goethe.) On the sheet of paper
which the poet holds is a poem by
Ludwig, which is probably intended
as an act of reverence to the person
who commissioned the portrait.

Neoclassical
Landscape Painting

Around 1800, Rome was the artistic
centre of German painting and the
source of many movements that
were to manifest themselves in the
art of the 19th century. After land-
scape painting had sunk more or
less to the level of the well-crafted
veduta in the 18th century, it flow-
ered anew in the hands of the Neo-
classicists in Rome in the form of
the heroic landscape. Influential in

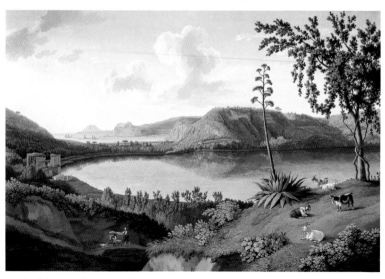

Jacob Philipp Hackert, Lago d'Averno, *1794, paper, 57.6 x 83.6 cm (10162)*

this respect were, on the one hand, the two great 17th-century French landscape painters in Rome, Nicolas Poussin and Claude Lorrain, with their depictions of classical antiquity, and, on the other hand, the 18th-century Dutch landscape painters. Initially, the subjects for the new Neoclassical landscapes were found in the Italian countryside. Before long, the regions of northern Europe and Greece also provided motifs, which are presented in a natural manner as an expression of eternal majesty and grandeur. Elements found in nature are transformed into idyllic, often stage-like spatial structures. The wealth of individual forms are captured with linear precision and clear color. Light and shade stand in sharp contrast to each other. The radiant, eternally blue sky becomes a token of the timeless, universal validity of nature, elevated to the level of God's Creation in pictorial form.

Goethe was the first biographer of **Jacob Philipp Hackert** (*b.* Prenzlau, 1737; *d.* San Pietro di Careggi, 1807), one of the central figures of the colony of German artists in Rome. In 1768, after completing his training in Berlin and Paris, Hackert moved to Italy, where he enjoyed international success with his landscape vedutas. He also painted scenes from nature – such as the *Lago d'Averno* – which, in their timeless serenity, far surpass his earlier landscapes. The smooth reflecting surface of the lake is framed by accurate botanical depictions of plants, such as the flowering aloe in the foreground, and by the ruins of a temple to Apollo on the left and the Bay of Pozzuoli in the background. Goats and a man driving a donkey, accentuate the bucolic, Arcadian character of this southern idyllic scene. There is no reference in the picture to the fact that in antiquity this crater lake was regarded as an entrance to the netherworld (Virgil, *Aeneid* IV).

After enjoying a liberal education, **Johann Christian Reinhart** (*b*. Hof/Saale, 1761; *d*. Rome, 1847) studied under Oeser at the Academy in Leipzig and under Klengel in Dresden. He was a friend of Schiller and had a profound interest in art theory. In 1789, Reinhart set out for Italy. *Callimachus' Invention of the Corinthian Capital* is his last landscape composition. Begun decades earlier, the picture was completed in 1846 at the request of Ludwig I. The painting depicts how the Attic sculptor Callimachus was inspired by a form of architectural decoration as during a walk. According to legend, Callimachus laid down his personal belongings beside a grave and covered them with a slab of stone. Over the course of time, the leaves of an acanthus plant grew from under the basket and curled over the corners of the slab.

Through this reference to an ancient legend, which was handed down by Vitruvius, and which inspired both Schinkel and Turner, Reinhart's ideal landscape becomes an expression of a noble idea: the birth of art from nature, or the sublimation of nature through art.

Josef Anton Koch (*b*. Obergibeln, Tyrol, 1768; *d*. Rome, 1839) was the son of a farmer in the Lech Valley in Tyrol and apparently revealed his astonishing talent for drawing when he was a herdboy. With the support of the local bishop, he attended the prestigious Karlsschule in Stuttgart, but finally escaped the constraints of the school – like Schiller – and traveled via Strasbourg to Switzerland. During the course of numerous hiking tours in the mountains, he drew many scenes from nature and collected study materials, which he used throughout his life. In 1794, he traveled to Italy and settled in Rome the following year. He was a close friend of Reinhart and at times worked in the same studio. The two painters are attributed with reinspiring the heroic landscape.

The Schmadri Falls was painted from sketches made in the Bernese Oberland. In this picture, the massive mountains, with their glaciers and waterfalls, soar up in sublime inaccessibility. It is an image of eternity and a symbol of untouched freedom. Koch himself descibed his experience of nature in the Alps in the following words: "Everything is

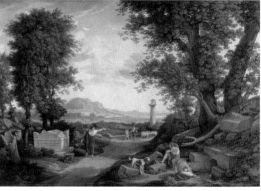

Johann Christian Reinhart, Callimachus' Invention of the Corinthian Capital, *1846, canvas, 65.4 x 135.2 cm (WAF 815)*

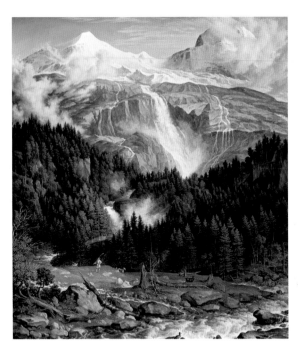

Josef Anton Koch,
The Schmadri Falls,
1821–22, canvas,
131.8 x 110 cm
(WAF 449)

complete unity in diversity. The Alps, veiled in clouds, wrapped in their gleaming white, Siberian-cold attire, raise their venerable ancient heads up to the heavens, which seem almost to rest upon them. Maternally, they care for these virgin regions, water them with innumerable springs and show compassion on this human paradise...." The picture was greatly acclaimed when shown in 1825 at an exhibition in Munich containing works by German artists in Rome. It was purchased in 1829 by Ludwig I.

Ludwig Richter (*b*. Dresden, 1803; *d*. Dresden, 1884) became acquainted with Koch's heroic landscapes during a stay in Rome between 1823 and 1826. Ultimately, however, Richter developed a Romantic view of nature. The studies for his first

oil painting, *The Watzmann*, were made en route to Italy. Richter executed the work in 1824 in Koch's studio, possibly influenced by that painter's *Schmadri Falls*. Unlike Koch's work, though, *The Watzmann* presents a far more pleasing, benevolent view of nature. Traces of human life can be seen scattered over the hillsides, from the hut next to the torrent to the chapel with its graveyard. As a result, large areas of the mountain, and the picture, appear hospitable and accessible. The snow-covered, icy peaks remain in the background as a picturesque group of distant high mountains.

Carl Rottmann (*b*. Heidelberg, 1797; *d*. Munich, 1850) painted the frescoes in the arcades of the Court Gardens in Munich for Ludwig I, depicting Italian landscapes. Four

examples from an ensuing Greek cycle, for which thirty-two paintings were proposed, hang in the entrance hall of the Neue Pinakothek. Rottmann executed this cycle between 1838 and 1850 in the ancient encaustic technique, a form of painting in which the pigments are mixed with wax. Rottmann was one of the first German painters to travel to Greece. The Greek cycle was preceded by the view of *Sikyon and Corinth*. It shows a plateau that drops steeply into a valley, which in turn leads to the distant sea. On the right of this desolate landscape are the remains of the acropolis of Sikyon, an ancient trading city. In the background, near the sea bay, the ruins of Corinth can be seen – the final traces of a past culture. The only living being in this landscape is the small wayfarer in the foreground, who acts as an observer. Here, the painter is depicting neither man's awe at the grandeur of nature nor the newly discovered freedom of the natural world. In its melancholy, this colossal natural landscape is a new kind of reflec-

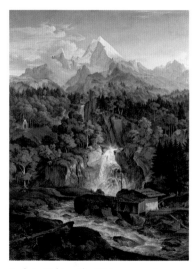

Ludwig Richter, The Watzmann, *1824, canvas, 120.2 x 93 cm (8983)*

tion on the irretrievability of ancient culture. At the same time, it is a depiction of eternal harmony, the power of nature, and the role of destiny, in which nature is perceived as neither Romantic nor Neoclassic. With such stylized depictions of this kind, Rottmann had a pioneering influence on 19th-century landscape painting.

Carl Rottmann, Sikyon and Corinth, *1836–38, canvas, 85.5 x 102 cm (WAF 843)*

The Nazarenes and German Artists in Rome

The desire for a return to artistic innocence, articulated around 1800, found a major source of expression in the group of artists known as the Nazarenes. The movement developed from a religious organization known as the *Lukasbund* or Brotherhood of St. Luke, which was founded in Vienna in 1809. In 1810, a number of young artists in Rome gathered around Franz Pforr and Friedrich Overbeck to form a quasi-monastic community in the monastery of S. Isidoro. Because of their "Old German" attire and long hair like Jesus of Nazareth, they were given the derisive nickname "Nazarenes." The group was united in its quest for a renewal of art – independent of the dictates of the academies – and in its wish to return to the principles of Raphael. Its ideal was a simple form of art, aspiring to the rules of beauty, free of emotion and illusion, and based on clear lines and pure colors. The artists were also united in their interest in the Middle Ages and in Old German and Dutch painting. It was their goal to create a new German art on a Christian basis, which would spring from a resolution of the polarities existing between Italy and the North, between Raphael and Dürer. This new artistic ideal found its programmatic expression in Overbeck's *Italia and Germania* of 1828. The first major project undertaken by the Nazarenes in Rome was the decoration of the Casa Bartholdy (1815–1818), the residence of the Prussian ambassador, in a fresco technique that was rarely used at that time.

The *Holy Family beneath the Portico* by **Friedrich Wilhelm von Schadow** (*b*. Berlin, 1788; *d*. Düsseldorf, 1862), a son of the sculptor Johann Gottfried Schadow, is a fine example of the combination of landscape and interior perspective -

Johann-Friedrich Overbeck, Italia and Germania, *1828, canvas, 94.4 x 104.7 cm (WAF 755)*

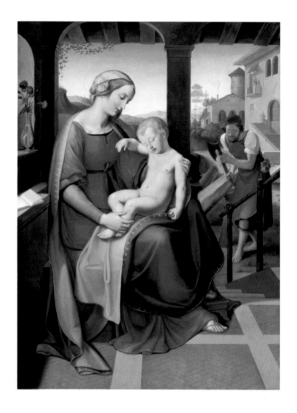

popular during the Italian Quattro-
cento. The picture is elaborated
with narrative motifs of the kind
found in Dutch Old Master paint-
ing. At the same time, the work
can be seen as a representation of
the artistic ideals of the Nazarenes.
In striving for innocence in art,
the artist – rather like Joseph, the
carpenter – seeks to create work
independently on a craft basis,
by grinding his own colors, for
example. Like Raphael, Schadow
places the main aim of Nazarene
art, Mary and her child, in the cen-
ter of the canvas. Not only did
almost all of the members of the
Nazarene brotherhood in Rome
convert to Catholicism, in which

they hoped to find a renewal of art,
but they also sought to regain pop-
ular religious painting as an art
form (cf. Overbeck's Bible illustra-
tions), through a new intense
veneration of the Virgin Mary. The
Nazarenes were extremely success-
ful with their religious, devotional
art. Ultimately, however, it degener-
ated into a kitschy exploitation of
the sentimental aspects of the sub-
ject and found its continuation in
20th-century pictorial prints.

The portrait of *Vittoria Caldoni
from Albano* by **Johann-Friedrich
Overbeck** (*b.* Lübeck, 1789; *d.*
Rome, 1869) also belongs in this
context. After being discovered in

Johann-Friedrich Overbeck, Vittoria Caldoni from Albano, *1821, canvas, 89 x 65.8 cm (WAF 757)*

1820, at the age of thirteen by August Kestner, the beautiful daughter of a poor winegrower became a popular model in the circle of the German artists in Rome, as a bust of her by Rudolph Schadow in the same room demonstrates. She is portrayed in a calm statuesque manner, her head supported on one hand in a pose reminiscent of Dürer's *Melencolia*. In this artistically simple arrangement, the girl's character is obscured by the allegorical content. Even the sickle, fruit, and field of grain behind her seem to be more in the nature of attributes than real objects from her everyday life. Vittoria Caldoni might be seen equally as a Christian saint – a peasant harvest saint, for example – or as a goddess of fertility from classical antiquity.

Rudolph (Ridolfo) Schadow (*b.* Rome, 1786; *d.* Rome, 1822) was the elder son of the famous Berlin sculptor Johann Gottfried Schadow. From 1811 on, Rudolph lived with his brother Wilhelm in Rome, where he took over Christian Daniel Rauch's sculpting studio and adopted Thorvaldsen's Neoclassical style. Schadow's reputation is based on his graceful depictions of young women, especially that of

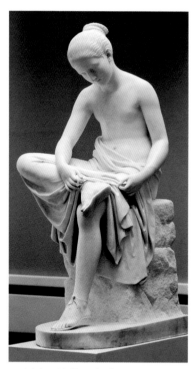

Rudolph (Ridolfo) Schadow, Woman Tying Her Sandal, 1813 (1817), marble, h. 118 cm (WAF B.24)

Domenico Quaglio (*b*. Munich, 1787; *d*. Hohenschwangau 1837) was trained as an architectural painter and is best known for his vedutas of Munich, in which he recorded many urban situations before they were altered as a result of the extensive building projects implemented by Ludwig I and his architect Leo von Klenze. Quaglio's *View of the Villa Malta in Rome* shows the house in its urban context, depicted tangibly close to the observer in the manner of Dillis. This simple house was the home and meeting place of the German artists in Rome, a circumstance that is indicated by two figures deep in conversation on the roof of the building. Ludwig I, who had rented the villa for an extended period of time as a holiday residence, purchased it on 26 March 1829. Goethe was one of the first

Woman Tying Her Sandal. He sculpted this figure for the first time in 1813 and created seven replicas, including the one exhibited in Munich, which was commissioned by Ludwig I in 1817. Her lithe limbs and the charming way in which she seems oblivious to everything about her lend this slender, delicate figure a captivating quality. She is veiled in an aura of youthful innocence, which is echoed by the white purity and immaculate smoothness of the marble. Schadow therewith leaves behind the strict, though strongly lyrical, aspects of Neoclassicism and achieves a new and tremendously successful figure with Romantic, sentient traits.

Domenico Quaglio, View of the Villa Malta in Rome, 1830, canvas, 62.8 x 82.3 cm (WAF 784)

people he informed of this. Reinhart depicted views of the "Eternal City" from the villa in four large-scale panorama paintings.

Biedermeier

The Biedermeier era extends roughly from the German wars of liberation (1813–1815) to the March Revolution of 1848. Politically, the term "Biedermeier" describes a period of restoration in which the German royal houses were able to return absolutist rule over a number of small autonomous states. During this period, the ruling houses sought to suppress the liberal, national-patriotic aspirations that the French Revolution had inspired. Economically, the Biedermeier age in Germany marks the beginning of the transition from an agrarian to an industrial society in the English mold. Socially, it was an age that witnessed a major step towards the creation of a middle-class society. Originally, "Biedermeier" was the name of a fictitious Swabian schoolmaster, from whose popular collection of songs and poems satirical examples were published in the Munich journal *Fliegende Blätter* between 1855 and 1857. Biedermeier, therefore, refers to a lower-middle-class, apolitical culture, the sober unpretentiousness of which was a product of the Enlightenment and the economic austerity of the times. Beidermeier was also an expression of a late-Romantic yearning for rural simplicity and naive naturalness. The Biedermeier era witnessed a resurgence of portrait, landscape, and genre painting. These forms of art did not enjoy very high esteem in the art academies; however, through new art societies, which became the centers of contemporary artistic developments, these painting categories rapidly grew in importance. In portraiture and genre painting, popular themes from everyday life were now found worthy of depiction. Elevated to a poetic or anecdotal level, they provided a reflection of bourgeois society. Landscape painters began to take an interest in the unspectacular aspects of nature, which were heightened by means of unusual lighting and soft, atmospheric effects.

Moritz von Schwind (*b*. Vienna, 1804; *d*. Niederpöcking, on Lake Starnberg, 1871) was the son of a high-ranking court official in Vienna. From 1821 to 1823, having abandoned his studies in philosophy, he studied at the Academy in Vienna under Schnorr von Carolsfeld, and from 1827 under Cornelius in Munich. Beginning in 1828, Schwind associated with the Viennese art circle around Spitzweg and received various commissions to paint historical frescoes. In the 1830s, he developed a new pictorial form in which individual paintings were set next to and above each other, grouped within a single specially designed frame, to form a thematically linked series of poetic events. Examples of this are *A Symphony* and *The Tale of Cinderella*.

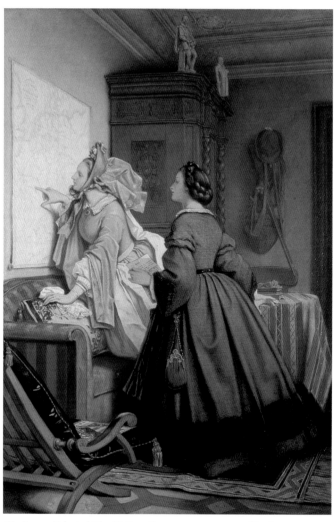

Moritz von Schwind, The Visit, *c.1855, canvas, 72 x 51 cm (8120)*

The Visit is one of his so-called travel pictures. These were small-scale occasional pieces, which he painted for economic reasons. The painting depicts a small, intimate scene, in which a female visitor from the city has arrived at a friend's house in the country. Both the hostess and guest are searching for a particular location on a large map hanging on the wall. In the harmony of the two female profiles, in the unison of their graceful movements, in the loving care with which their attire and the interior are depicted, in the pictorial style and the restrained yet richly differentiated color. The scene is an example of Schwind's receptiveness to new, popular themes in his compositions.

In *Shower of Rain in Partenkirchen* by **Heinrich Bürkel** (*b.* Pirmasens, 1802; *d.* Munich, 1869), the

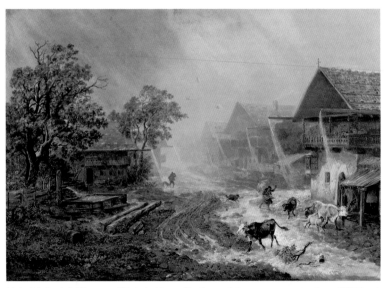

Heinrich Bürkel, Shower of Rain in Partenkirchen, *1838, canvas, 44 x 60.8 cm (WAF 133)*

painter's interest lies in an almost journalistic depiction of a violent cloudburst in which the wind drives the rain in great torrents of water, transforming the paths into gutters. The juxtaposition of figures fleeing the pouring rain with flowers that seem unaffected by the storm, seems somewhat incongruous. Nevertheless, the scene is remarkably well documented. The details recede behind a homogeneous overall impression. From 1820 on, Bürkel studied at the Munich Academy, and beginning in 1825, he exhibited his works in the exhibitions organized by the society of fine arts (Kunstverein). His paintings of the everyday life of people in Upper Bavaria were internationally successful.

Ferdinand Georg Waldmüller
(*b.* Vienna, 1793; *d.* Hinterbrühl near Vienna, 1865) attended the class for landscape painting at the Vienna Academy. Later, however, he rejected his academic education, on the grounds that it taught artists only how to copy the art of the Old Masters. In various writings, he propagated the exclusive study of nature. Waldmüller's main areas of work were portraiture and landscape painting. In later years, he also devoted increasing attention to rural genre scenes. The fascinating quality of the small portrait of *The Artist's Son, Ferdinand, with a Dog* lies in its intensity, convincingly lifelike portrayal of the young man, and masterly formal interplay between foreground and background, culture and nature. Dressed like an adult, but still youthfully intent and open in his bearing, the young man stands before a broad, cultivated landscape – accompanied by a trained hunting dog – beyond which an area of untamed nature rises in the background.

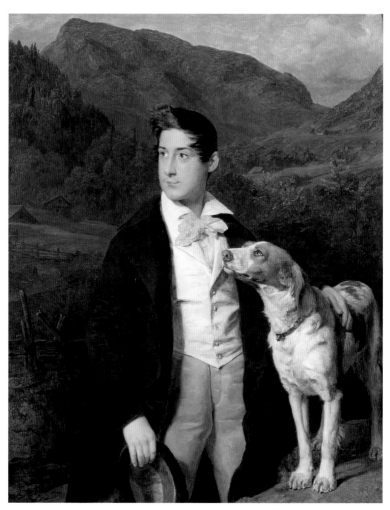

Ferdinand Georg Waldmüller, The Artist's Son, Ferdinand, with a Dog, *1836, panel, 39.2 x 31.2 cm (9274)*

The picture *Early Spring in the Viennese Woods*, painted more than twenty years later, is not a clear, concise narrative depiction of nature. The scene comprises a number of momentary, lightly painted details. Beneath the tall beeches, still bare from winter, two girls search for the first violets, which they bind into posies and hand, half-shyly, half-pertly, to two small boys. The slow awakening of nature has its counterpart in the cheerful, innocent play of the children. In a similar way, the color of the violets, almost concealed among the grays, browns, and greens of the forest, echoes the blue and red of the children's clothes, glowing between the branches and trunks of the trees. In paintings of this kind, Waldmüller's interest lay not so much in the depiction of country motifs as in the naiveté of child-

Ferdinand Georg Waldmüller, Early Spring in the Viennese Woods, *1860–65, panel, 54.2 x 67.9 cm (9324)*

hood, which, following Rousseau, he believed to be a state especially close to nature. Scenes like this are a visualization of "a segment of life," for "no feeling heart could resist this magic." (Waldmüller, *Andeutungen zur Belebung der vaterländischen Kunst*, 1857)

In his portrait of the *Forest Inspector C. L. von Schönberg,* **Ferdinand von Rayski** (*b.* Pegau, Saxony, 1806; *d.* Dresden, 1890) achieves a remarkable unity of personality and rank through composition and color. Portrayed at almost life-size in a relaxed pose, the subject appears virtually inseparable from the trunk of the tree against which he is leaning. Nevertheless, the observer perceives him as a prominent figure whose strikingly lit countenance reveals that he is alert and fully in control of his district. With this

calm, objective, yet arresting portrayal of the forest inspector, von Rayski follows in the footsteps of Anton Graff. Von Rayski studied for

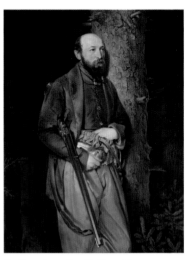

Ferdinand von Rayski, Forest Inspector C. L. von Schönberg, *1850, canvas, 134.5 x 102.2 cm (1789)*

Friedrich von Amerling, Maiden with a Straw Hat, *c.1835, canvas, 59 x 47 cm (9999)*

a time at the Dresden Academy, stayed in Paris from 1834 to 1835, and made a name for himself in later years as a much sought-after portraitist of the nobility.

Painted in Vienna during the Biedermeier era, portrait of a *Maiden with a Straw Hat* by **Friedrich von Amerling** (*b*. Vienna, 1803; *d*. Vienna, 1887), is an enchanting hymn to female beauty. The spontaneity with which he captures the wistful look of the young woman, and the intimacy of the pictorial detail lend the subject an almost tangible proximity. The warm, ivory color of the girl's immaculate skin is complemented by the opalescence of her gleaming string of pearls. The red scarf draped over the girl's shoulders is reflected in her glowing cheeks and lends her, together with

the green ribbon round her hat, a peach-like freshness. After studying at the Vienna Academy, von Amerling spent some time in England, where he was influenced by the fine quality of Lawrence's portrait painting. In the 1830s, von Amerling traveled to Rome and Venice, as well as to the Netherlands, where he studied the work of Rubens.

Portrait of Fanny Ebers by **Friedrich Wilhelm von Schadow** (*b*. Berlin, 1788; *d*. Düsseldorf, 1862) is an example of how the Nazarenes in Rome exerted a belated influence even during the early Biedermeier period in Berlin. The slim, long-limbed subject of this picture, the wife of a financier, is depicted in an interior that opens onto an Italian landscape in the style of the early Cinquecento. Because of the

Friedrich Wilhelm von Schadow, Portrait of Fanny Ebers, *1826, canvas, 175 x 111 cm (9671)*

restrained, graceful, finely drawn linearity of her figure, and the enamel-like shimmer of her deep-red dress, she is the most precious object in this exquisite room. Nature is also represented in a cultivated manner, in the form of the potted plants, the bowl of fruit, and the parrot. Friedrich Wilhelm von Schadow became a professor at the Berlin Academy in 1819 and succeeded Cornelius in 1826 as director of the Düsseldorf Academy.

Late Romanticism and Realism in France

Théodore Géricault and Eugène Delacroix are regarded as two of the most important representatives of French Romanticism. They responded to the restrained smoothness and noble coolness of the Neoclassicists – from Jacques Louis David to Ingres – with sensual color and passionate and dramatic content and composition. This development was inspired by a renewed interest in the works of Rubens and the Venetians. Constable, who made a great impression at the Salon of 1824 in Paris, was also influential since his scenes concentrated on the evocation of atmospheric impressions. Both Géricault and Delacroix found their themes in exciting literary sources and topical events. Géricault's *Raft of the "Medusa"* of 1819 and Delacroix's *28th July, Liberty Leading the People* of 1830 are perhaps the two most famous examples of this. Delacroix in particular returned to expressive line and color that the Impressionists later acknowledged as having liberated art from the shackles of the academies. Not surprisingly, Delacroix became a leading figure for the Impressionists.

In his painting *Deployment of Artillery*, **Théodore Géricault** (*b*. Rouen, 1791; *d*. Paris, 1824) depicts a military event that has been condensed into a single dramatic moment. An explosion serves as a light source that reveals a large cannon drawn by four horses. There is no more to be seen on the battlefield than a few cannons firing in the distance.

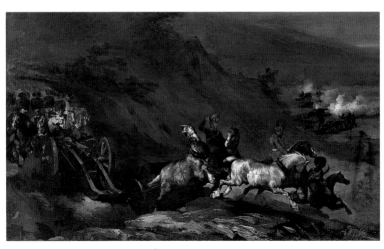

Théodore Géricault, Deployment of Artillery, *c.1814, canvas, 89.2 x 143.7 cm (8583)*

Géricault's interest lies in the tension of the scene and the momentary release of pent up emotions. These aspects are concentrated in masterly fashion in the glinting bodies of the horses in the foreground. Géricault had a passion for horses and was an extremely gifted equine portraitist. He stayed in England from 1820 to 1822 and died at a young age in Paris after a long illness resulting from a riding accident.

In his monumental painting *Heroic Landscape with Fishermen*, **Géricault** turns his attention to the genre of classical landscape. The subject occupies a special place in his œuvre, the main emphasis of which lay in depictions of human beings and animals. The tall pine tree in the foreground serves as a visual focus and framing element. Beneath the tree, a broad river flows into the landscape, past structures that resemble stage sets

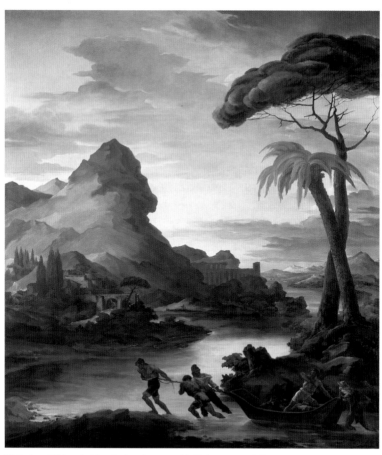

Théodore Géricault, Heroic Landscape with Fishermen, *1818, canvas, 249.5 x 217.5 cm (14561))*

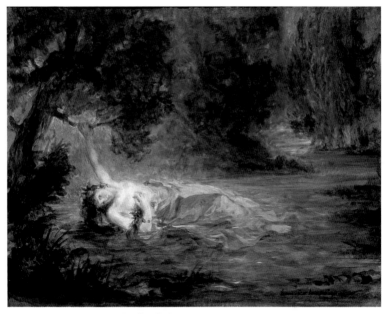

Eugène Delacroix, The Death of Ophelia, *1838, canvas, 37.9 x 45.9 cm (12764)*

– in the way they are inserted into the picture – a bridge and a half-ruined aqueduct. A significant aspect of the painting is the terse, planar treatment of the individual forms and the pale lighting. As a result of both, the scene possesses an unreal, abstract quality.

Géricault painted this picture in 1818 as one section of a three-part representation of the times of day. The paintings were part of the interior decorations of the house of his friend Marceau in Villers-Cotterets near Paris.

Eugène Delacroix (*b.* Charenton-St. Maurice, Seine, 1798; *d.* Paris, 1863) took a Romantic subject for his painting *The Death of Ophelia*. The theme is the well-known event described in Shakespeare's *Hamlet* (Act IV, Scene 7): Ophelia's death by drowning. The picture is not a narrative representation, but the depiction of an existential moment, showing the heroine hovering between life and death. She is already drifting in the water, but seems to cling to life by clutching the slender branch of a tree. The fatal outcome is certain, however, as is indicated by the noticeably pale color, ranging from subdued greens to gray and white.

Delacroix was inspired to paint *Clorinde Freeing Olindo and Sofronia* by a dramatic scene in the second canto of Torquato Tasso's *Gerusalemme Liberata* of 1581, in which the Renaissance poet describes the conquest of Jerusalem in 1099 during the First Crusade. Sofronia, a Christian woman who recovered a picture of the Virgin Mary that had been stolen by an infidel, has been

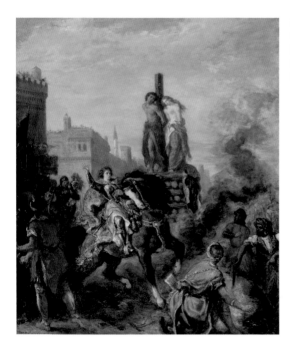

Eugène Delacroix,
Clorinde Freeing
Olindo and Sofronia,
1853–56, canvas,
101 x 82 cm (13165)

sentenced to death at the stake, together with Olindo, who, in his love for her, also confessed to the deed. At the very last moment, after the fire has been lit, Clorinde, a female Saracen warrior, manages to free the couple. The picture was painted circa 1853–56 and provides

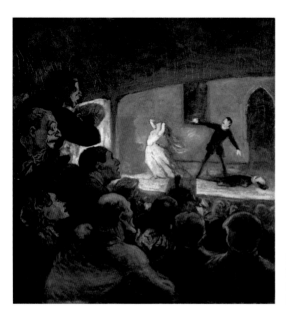

Honoré Daumier,
The Drama, *c.1860,*
canvas, 97.5 x 90.4 cm
(8697)

an example of Delacroix's furious brushwork, dramatic composition, and exciting and idiosyncratic color. The painting is not built up from clearly defined forms of equal weight, but consists of a polyphony of colors and tones that are articulated in detail only at specific points.

Honoré Daumier (*b*. Marseilles, 1808; *d*. Valmondois, Oise, 1879) grew up in relative poverty. At the age of twelve, he became the messenger of a bailiff and later worked for a bookseller. Apart from attending an evening course, he trained his talent for drawing by copying works in the Louvre. Having received training in lithography, he initially produced lithographic vignettes. After the July Revolution of 1831, he was employed by the satirical journals *La Caricature* and *Le Charivari*, for which, over a period of many years, he produced innumerable psychologically pointed caricatures, in the form of lithographs and woodcuts. Daumier was known first and foremost as a French political caricaturist in a country torn between monarchy and republicanism. Less well known are his small-scale oil paintings, which he executed between 1862 and 1868, of which the Neue Pinakothek possesses two outstanding examples.

The subject of *The Drama* is the power of demagogy and the impotence of the individual when part of the crowd. The onlookers are completely under the spell of the drama of jealousy which is slowly coming to a climax on the stage. They are depicted as uniform figures reduced to little more than silhouettes and patches of color, arranged in a series of layers. Within the group of grotesque, grimacing, boldly delineated profiles – whose attention is focused on the delicate form of the actress on the stage – individual personalities may be decerned. The dull colors of the mass of figures – limited to a narrow spectrum of gray and brown tones – contrast with those of the actress, in whom colors and brushwork become more active, dynamic elements of the composition. In this way, Daumier achieves a intensity that approaches the level of conceptual expression.

Daumier's *Don Quixote* reveals an even greater degree of abbreviation in its composition and brushwork. Here, the focus is on volume and surface, caricatured exaggeration and pure content. The charger, for example, however decrepit, has a three-dimensional presence. In contrast, the knight "of the rueful countenance," appears to be a more planar, immaterial being, reflecting the intangibility of his heroic, visionary world. The three broad zones of color – blue, brown, and yellow – which form the background to these figures refer to the desert-like landscapes of the knight's odyssey. Don Quixote, usually accompanied by his faithful servant Sancho Panza, was an extremely popular figure in early 19th-century French art. Throughout his creative life, Daumier was preoccupied with this subject, in which he possibly saw an expression of his own existence as an artist.

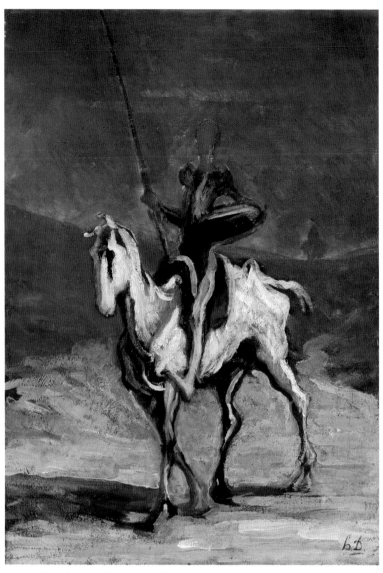

Honoré Daumier, Don Quixote, *c.1868, canvas, 52.2 x 32.8 cm (8698)*

Daumier's œuvre also includes sculpture, of which this delicate bozzetto-like statuette modeled in clay is an example. The figure of *Ratapoil* was created in the context of the fall of the Second Republic, brought on by Louis Napolean's violent coup in 1851. The piece was initially developed as a satirical lithograph depicting a reactionary chauvinist. In sculptural form, the skeletal form wrapped in a long coat and concealing a crude club behind its back, is transformed into an ominous figure. In its aggressive corporeality, attenuated limbs extending out in a spidery manner, the sculpture radiates

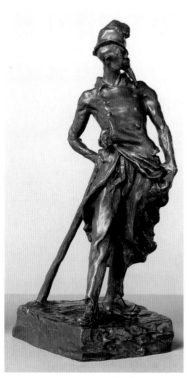

Honoré Daumier, Ratapoil, *after 1851, bronze, h. 43.5 cm (B.870)*

malevolence. The oppressive, disturbing immediacy of the figure makes it a simultaneously sensuous and conceptual embodiment of Bonapartism. None of Daumier's sculptures was cast in bronze during his lifetime. The earliest castings, to which this statuette belongs, date from the 1890s.

The Barbizon School

In the 19th century, the extensive Forest of Fontainebleau, south of Paris, was still largely in a natural state. On it edge lies the village of Barbizon, which at the beginning of the 1830s became the meeting place of a number of young painters. The first artists to go there were Corot, Diaz de la Peña, Rousseau, and Daubigny. They were followed by Courbet and Barye. Later, Rousseau and Millet spent much of the year in Barbizon. All of them were united in their interest in unspoiled nature, which restricted their subject matter to the changing moods of the day, the seasons, and the weather. This view of the world prepared the ground for a new, simple veracity in art. The paintings of the so-called Barbizon School are devoted to a genuine experience of nature, one in which man still belongs to this world and the divine order. The works of this school were inspired by 17th-century Dutch landscape painting and by the new pictorialism and atmospheric translucence associated with English painting, especially that of Constable. Millet also created simple but dignified allegorical depictions of humans in

a style that was later adopted by van Gogh, who developed it in his own inimitable manner. Ultimately, Barbizon became a synomym for "plein-air" painting and was associated with modest subjects and the use of specific techniques. Two examples are the spontaneous application of paint with a palette knife, which lent a work an almost material quality or, alternatively, a thin, fluid application with swift brushstrokes. The Barbizon School may therefore have paved the way for Impressionism in the second half of the century.

With its bizarre oaks and silvery tree trunks, between which huge sandstone boulders lie scattered, *Clearing in the Forest of Fontainebleau* by **Narcisse Diaz de la Peña** (*b*. Bordeaux, 1809; *d*. Mentone, 1876) presents an isolated segment of this richly varied area of woodland. The forest, which at that time was far more extensive than it is today, is shown here exposed to the elemental forces of nature. The sky is dominated by a receding storm, as the dramatic cloud formations indicate, but the water in the stream rushing through the center of the picture already gleams in the light of the returning sun. The subject and composition of the painting are reminiscent of Jacob van Ruisdael, the most famous Dutch landscape painter of the 17th century, whose gloomy, agitated forest landscapes provided the Barbizon painters with important models for their view of nature.

In contrast, the *Weir near Optevoz* by **Gustave Courbet** (*b*. Ornans, Doubs, 1819; *d*. la Tour de Peilz, Vevey, Switzerland, 1877) is a depic-

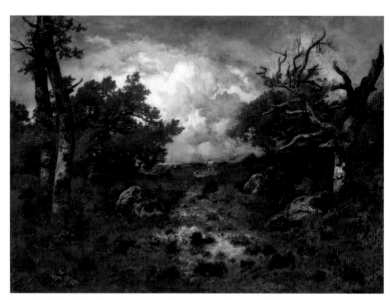

Narcisse Diaz de la Peña, Clearing in the Forest of Fontainebleau, *1868, canvas, 83.3 x 112 cm (12523)*

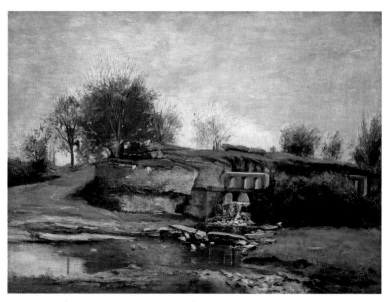

Gustave Courbet, Weir near Optevoz, *1854(?), canvas, 63.6 x 84.5 cm (8584)*

tion of a meadow with trees beside a calmly flowing river, which narrows temporarily so that it may flow through the two-tiered arches of an old weir. The scene is set beneath a broad autumnal sky. The bare rocky landscape and limestone weir near Lyons were popular subjects for painters, as two pictures of the same scene by Daubigny show. Technical investigations have revealed that this painting is a collaborative work by Courbet and Daubigny – a practice also found among the Impressionists and the circle about Leibl. The details of the weir, was built up on the canvas with a palette, may be attributed to Courbet. The trees and the sky, on the other hand, were painted by Daubigny. The two artists had been friends since 1848 and painted together in this area for the first time in 1854.

Gustave Courbet attracted public attention in Paris on many occasions: through the spectacular presentation of his paintings at exhibitions mounted to rival those of the official Salon; in his role as leader of the realist movement and as a radical advocate of civil rights and liberties; and finally because of the subject matter of the paintings themselves. In general they were misunderstood because of their unusual content and coarse execution – Courbet was fond of using a palette knife to apply paint. Following the violent suppression of the rising of the Commune in 1871, Courbet was accused of inciting people to destroy the obelisk in the Place Vendôme and sentenced to six months in prison. During his confinement, he painted still lifes of the fruit and flowers his sister brought to him in prison. The *Still*

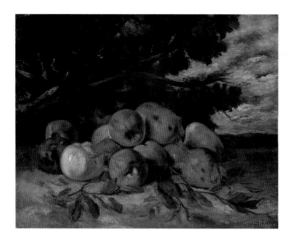

Gustave Courbet, Still Life with Apples, *1871, canvas, 50.4 x 63.4 cm (8623)*

Life with Apples in Munich was probably painted at this time. One of its striking features is the combination of still life and landscape – with a tree thrown to the ground by a storm and scudding clouds above the low horizon. The two genres are rendered in dramatic chiaroscuro and unusually monumental form. The wormholes in the fruit and leaves torn from the trees by the storm might refer to the destruction caused by external agents. In this light, the still life may be seen as a reflection of the limitations of Courbet's artistic life at this time.

Charles-François Daubigny (*b*. Paris, 1817; *d*. Paris, 1878) spent part of his childhood in the country and had to earn his own living at an early age. He did so, like Daumier, by drawing vignettes for publishing houses, but also by restoring the Palace of Versailles and paintings in the Louvre. As early as the 1830s,

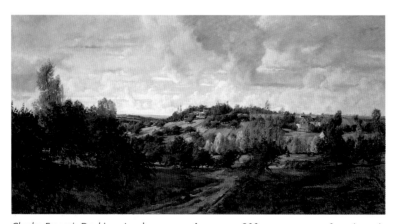

Charles-François Daubigny, Landscape near Auvers, *c. 1866, canvas, 120 x 226 cm (14994)*

he had sketched from nature in Barbizon. In 1860, he settled in Auvers-sur-Oise, as Pissarro, Cézanne, and van Gogh would later do. Daubigny was a friend of Corot and Courbet and painted with both of them, especially in the area around Lyons. His *Landscape near Auvers*, painted in the 1860s, is fascinating because of the atmospheric freshness of its early autumnal mood and richly articulated spectrum of green and brown tones. The picture is one of the earliest examples of the remarkably large canvases that Daubigny painted from nature in the 1860s.

Camille Corot (*b*. Paris, 1796; *d*. Paris, 1875) was the son of a cloth merchant and learned the trade himself. Only at the age of twenty-six did he decide to devote himself entirely to painting. A legacy from his parents freed him of the need to earn his living. By the 1820s, he was already painting studies from nature in the Forest of Fontaine-bleau, and he was to return there to work on many occasions. The

Bridge and Mill in Mantes reveals a typical feature of Corot's work at this time: the silver-grey color scheme, against which the blue skirt of the female figure shines as an emphatic spot of color. Commenting on this technique Corot said: "In every picture, there is a bright, luminous point; but there may be only one. You can set it where you wish: in a cloud, in an area of water, or on a person's cap. But there may be only one tone of this value." The painting's composition was originally based on the tension between the sharply drawn edge of a house in the left foreground (since painted over), and the block-like volume of a mill on the right. Corot's technique consisted in part of broad brushstrokes and a swift application of paint, made possible by thinning it to a watercolor-like consistency. This and the sureness of his touch, with which he captured subdued yet lively moods and atmospheric effects, gained him the admiration of the Impressionists, with whom he was in contact from the 1860s onwards.

Camille Corot, Bridge and Mill in Mantes, *c.1860, canvas, 25.5 x 33.4 cm (8844)*

69

Jean François Millet, Farmer Inserting a Graft on a Tree, *1855, canvas, 80.5 x 100 cm (14556)*

Jean François Millet (*b*. Gruchy, 1814; *d*. Barbizon, 1875) was the son of a well-to-do farming family in Normandy. His ability to draw was recognized and supported at an early age. In 1837, he was awarded a scholarship to study in Paris, where he came into contact with the Barbizon School of painters, specifically Narcisse Diaz and Théodore Rousseau who became his special friends. Millet's own leanings were not towards natural landscape painting, however. His interest was in depicting peasants and farming people, whom he regarded as guarantors of the community of man over the generations. In his painting *Farmer Inserting a Graft on a Tree*, for example, he depicts a young man grafting a young sprig onto an old stem. Compositionally and contentwise,

his actions are complemented by the young woman, bearing a baby on her hip, who watches the man. The subdued symbolic content of the action is echoed by the earthy colors, modulated in masterly fashion that allows the brighter tones to gleam warmly, yet with the restraint of spring. This simple allegory was inspired by a verse from Virgil's *Georgics*: "Graft, Daphne, the pear tree; your grandchildren will harvest the fruit." Millet's transformation of rustic figures into everyday heroes and the monumentalization they undergo as a result, were concepts van Gogh was to adopt later and develop in his own personal way. Millet's friend Théodore Rousseau, the leading figure among the circle of Barbizon painters, admired the painting so much that he purchased it from the artist the same

year it was exhibited at the World Exhibition in Paris. On the strength of this picture, the official jury also expressed great praise of Millet and placed him in the tradition of Raphael and Andrea del Sarto.

Auguste Rodin (*b*. Paris, 1840; *d*. Meudon, 1917) studied at the Ecole des Arts Décoratifs and was rejected three times by the Ecole des Beaux-Arts. He was influenced by the lively naturalism of Louis Barye, the most famous French sculptor of animals. The decisive experience in Rodin's career, however, was his encounter with the art of Michelangelo in Florence and Rome in 1875. According to the artist himself, this experience liberated him from the confines of academic art. The first important effects of Rodin's study of the Renaissance master can be seen in his outstanding early work *Man with a Broken Nose (Mask)*. In this piece, the sculptor combines the simple realism of his day, influenced by social theory, with a twofold historical goal. The sculpture has its origins in an odd character from the horse market in Paris, near which Rodin lived, at that time, in humble lodgings. He also introduced certain of Michelangelo's own facial features, which he took from a portrait by Daniele da Volterra. These are complemented by a faint resemblance to sculptures of the classical philosopher Socrates: the style of the hair and the beard, and the narrow antique headband. Besides all this, there was perhaps an underlying intention to create a subtle self-portrait, since at an early age Rodin's appearance had been compared with that of Michelan-

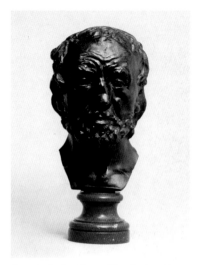

Auguste Rodin, Man with a Broken Nose (Mask), *1863, bronze, h. 30.5 cm (L.2092)*

gelo. The sculptor presents the head of a simple man marked by the trials of a hard life – he is not dull and stolid, but furrowed and broken. Treated as a mass that has grown from the inside out, this injured, sensitive, living face is a heartfelt expression of humanity ennobled by life and suffering. The head, in the form of an open plaster of Paris mask, was rejected by the Salon of 1864. However, in 1880, Rodin was awarded a gold medal at an exhibition in Nice for the version in bronze.

Henri Fantin-Latour (*b*. Grenoble, 1836; *d*. Buré, Orne, 1904) was the son of an Italian mother and a Russian father. He studied in the studio of Courbet and other artists. In the course of his various stays in England, he discovered the art of the Pre-Raphaelites and was fascinated by their symbolism and the subtlety of their splendid colors, which were

Henri Fantin-Latour, Still Life with Flowers, *c.1875, canvas, 49 x 65 cm (12572)*

achieved by painting on canvas that had a wet white ground. The radiant colors of the tight bouquet in Fantin-Latour's *Still Life with Flowers* shimmer against a dark background in a suggestive manner.

However, the flowers are not painted in realistic detail and the application of paint is much freer and impasto-like: the petals are articulated by means of densely laid color.

Late Romanticism and Realism in Germany

The painters Menzel, Achenbach, and Spitzweg were among the leading artistic figures of their time in Berlin, Düsseldorf, and Munich – the principal centers of art in Germany in the second half of the 19th century. Each in his own way gave expression to the confluence of Romanticism with a newly emerging realism demonstrating the many ways in which these two artistic currents were related to everyday life.

Perhaps the most important German painter of this time was Adolph von Menzel (*b.* Breslau/Wrocław, 1815; *d.* Berlin, 1905). His paintings range from portraits, landscapes, and decisive moments in history to anecdotal depictions of society and simple interior scenes with details of everyday life.

Menzel's treatment of these different subjects was informed by his intense observation of them and

Adolph von Menzel,
Sitting Room with the
Artist's Sister, *1847,
paper, 46.1 x 31.6 cm
(8499)*

his powerful of compositions, in which light, and its reflection and refraction into a rich array of tonal values plays a major role.

Sitting Room with the Artist's Sister is an outstanding example of the painter's intuitive gift for observation and his light, atmospheric style of painting, which anticipated Impressionism. This may be seen in a series of paintings executed in the 1840s for his family. In the present picture, von Menzel's 15-year-old sister Emilie is portrayed against the door frame. She appears to have been transported to a place known only to herself, somewhere between the shelter of home, where her mother sits sewing by lamplight, and the external world of dusk, into which she gazes with a mixture of curiosity and hesitance. In this impressionistic image of evening, von Menzel intimately and affectionately catches the tran-

sition from childhood to adulthood in an unassuming and almost incidental manner.

In the 1870s, Menzel was a frequent guest in the Hofgastein villa of a Berlin banker with whom he was on friendly terms. *Procession in Hofgastein*, painted in 1880, was based on numerous studies and sketches the artist made at this time. The festive, colorful procession has nearly reached its end. Men bearing banners head towards a church, followed by the Baroque baldachin, beneath which the monstrance is borne. Behind this, a long train of believers slowly emerges into the light from the darkness of the village street. In the foreground is a crowd of people, consisting of devout natives of the village and curious onlookers. Without moralizing, Menzel documents the confrontation between an open urban society and a rural culture

Adolph von Menzel, Procession in Hofgastein, *1880, canvas, 51.3 x 70.2 cm (L.817)*

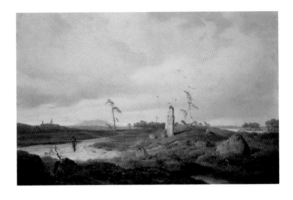

that still retains its traditions and religious beliefs. His real interest, however, is the summery atmosphere, enhanced by the Baroque richness and splendour of this special occasion.

Andreas Achenbach (*b.* Kassel, 1815; *d.* Düsseldorf, 1910) was a precocious talent and a pupil of Schirmer at the Düsseldorf Academy. Much of his work combines elements of the Romantic landscape with the dramatic qualities of 17th-century Dutch landscape painting, even though his style was initially much harder and reflected a more sober observation of his subjects. Later, he was famous for his realistic atmospheric paintings, especially landscapes from the Lower Rhine and coastal scenes, painted with quick, broad brushstrokes. In his early *Landscape with Rune Stone*, the bare scene, punctuated by only a few storm-torn trees, is extended into an allegory of life in the Romantic tradition through the rune stone that recalls prehistoric times. The broad sandy road that quickly diminishes to a narrow path – on which a solitary figure can be seen – might be an allusion to the winding path of life.

Carl Spitzweg (*b.* Munich, 1808; *d.* Munich, 1885) is regarded as a master of small-scale genre painting, in which he was fond of depicting – with a fine, ambiguous sense of humour – anecdotal scenes of the narrow-mindedness of bourgeois life in the so-called good old days. A pharmacist and self-taught painter, he was able to devote himself entirely to painting after an inheritance from his father made him financially independent. Spitzweg was a friend of Eduard Schleich, Christian Morgenstern, and Dietrich Langko and was at home in the circles of modern landscape and genre painters who had brought the Barbizon School's new concepts of *plein-air* painting to Munich.

The Poor Poet is a humorous satire on lofty poetic ambitions that fail due to a lack of artistic ability, as well as the wretchedness of a reality in which bundles of manuscripts ultimately serve to heat the stove. This painting might also be interpreted as an early

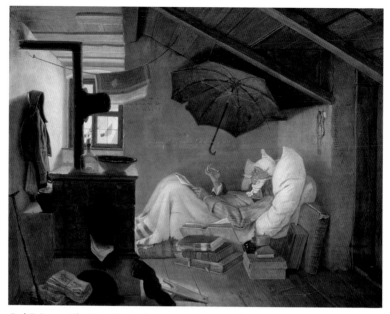

Carl Spitzweg, The Poor Poet, *1839, canvas, 36.2 x 44.6 cm (7751)*

example of Spitzweg's artistic position. With his precise depiction of the attic, down to the very fleas which the poet is cracking between the tips of his outstretched fingers, the painter reveals himself to be a realist. In his blind enthusiasm, the poet could also be seen as a representative of academic idealism, which has its parallels in the work of academicians and the monumental style of painting they

Carl Spitzweg, The Boarding School Excursion, *c.1872, canvas, 32.1 x 54.1 cm (11995)*

taught. Epitomized by the school around Cornelius in Munich, it was a form of painting that Spitzweg and his friends rejected, but in view of the fact that Spitzweg himself was made an honorary member of the Academy in 1868, this polarity should not be underestimated.

The Boarding School Excursion depicts a summer landscape beneath a broad sky. The scene opens out on the right to an area of untouched nature bathed in light. On the left of the painting is a town, over which rain clouds are receding. Set within this landscape are various figures: a soldier strolling with his betrothed, a group of farming people, almost hidden in the shade of a bush, taking a midday rest, and, at the center of the painting, a party of young boarding school pupils in the care of two nuns with parasols. Seen in conjunction with the other figures of this scene, the loving depiction of the girls, represents an anecdotal enrichment of the subject through the creation of character types. The painter's real interest here, however, is the bright, summery atmosphere hovering over the landscape, which he captures with light brushstrokes and a finely modulated color. Outdoor atmospheric scenes of this kind, which were based on numerous studies of nature, reveal Spitzweg's interest in modern French and English *plein-air* painting, with which he became acquainted on his travels.

Eduard Schleich the Elder (*b.* Haarbach, 1812; *d.* Munich, 1874) attended the Munich Academy at the age of fifteen but was soon dismissed because of his "complete lack of talent." Together with Dietrich Langko, Adolf Lier, and Christian Morgenstern, and specifically with his friend Carl Spitzeg, he undertook a number of journeys. These included a trip to Paris in 1851, where Schleich and Spitzweg found confirmation for their own concepts of painting as well as new ideas in the Barbizon circle. Schleich also explored many areas in Upper Bavaria and went on extensive hik-

Eduard Schleich the Elder, Ammersee with a View of the Mountains, *after 1865, panel, 48 x 99.3 cm (7687)*

ing tours. In his painting *Ammersee with a View of the Mountains*, emphasis is placed on the interplay of light and shade in the intense formation of low, hanging clouds. The landscape itself, with its broad lake set before a mountain, is a reflection of atmospheric events, to which humans, including the fisherman in a boat in the foreground, are completely subordinated. Schleich developed a special technique for landscapes of this kind, in which lighting plays a dominant role. He glazed the foreground and, using the end of a brush handle, scratched the paint down to the white ground to create highlights. The sky, in contrast, was built up with a palette knife into areas of thick impasto.

In his landscape paintings, **Adolf Heinrich Lier** (*b*. Herrnhut, 1826; *d*. Vahrn, Alto Adige, 1882) borrowed heavily from Eduard Schleich the Elder. Lier, however, was less interested in capturing impressions of broad scenes flooded with light than in panoramic elaborations of selected details in a landscape. He sought to achieve a satisfying depiction of rural scenes in all their variety. His *Summer Landscape near Lake Starnberg* is a fine example of this. This extensive landscape, set against the backdrop of the Alps, is painted with broad brushstrokes in scumbled green tones and interspersed with trees and clumps of bushes. The foreground has a number of anecdotally enlivening elements: a small, but colorful, line of people, a haywain, and a hunter. However, the landscape does not merge into an impressive sky, as is the case in Schleich's picture. Here, it is terminated by the chain of mountains in the distance and the sky above, all of which lend the scene a calm, tranquil, atmosphere.

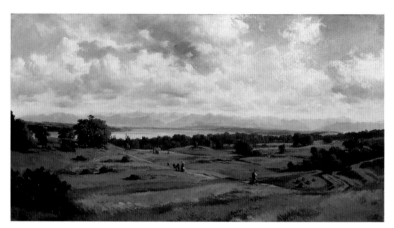

Adolf Heinrich Lier, Summer Landscape near Lake Starnberg, *1857–58, paper, 42.5 x 76 cm (9276)*

History Painting and *Gründerzeit*

In the nineteen oil sketches he painted between 1848 and 1854, **Wilhelm von Kaulbach** (*b*. Arolsen, Waldeck, 1804; *d*. Munich, 1874) paid tribute once more to King Ludwig I as a collector and patron of the arts. These cartoons were to form the basis of decorations on the outside of the former Neue Pinakothek, the foundation stone of which had been laid in 1846. *King Ludwig I, Surrounded by Artists and Scholars, Descends from the Throne to View the Sculptures and Paintings Presented to Him* shows the King of Bavaria in the midst of works of art from classical antiquity and the Middle Ages, his main areas of interest. The scene is set before the Alte Pinakothek, the Glyptothek, and the State Library. Kaulbach, who was court painter from 1837 on, and director of the Academy from 1849 on, here presents Ludwig in a questionable light as the

key figure in contemporary artistic developments in Munich. In its expression of servility and in the absolute loyalty of the homage paid by the various arts to the idealized ruler – who had already abdicated in 1848 – the cartoon is not far removed from a contemporary satire in the popular Munich weekly magazine *Die Fliegenden Blätter*. The concept of the unification of the arts as the symbol of an ideal state – conceivable in the Romantic age only as a vision, as expressed by Schinkel, for example – had by the middle of the century become an anachronism. Despite the topical overtones in this painting, Kaulbach points to a new and significant development in art in the future: its removal from the aesthetic control of the museums.

Shortly before this, Kaulbach had painted *The Destruction of Jerusalem by the Emperor Titus*, an

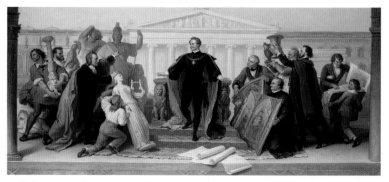

Wilhelm von Kaulbach, King Ludwig I, Surrounded by Artists and Scholars, Descends from the Throne to View the Sculptures and Paintings Presented to Him, *1848, canvas, 78.5 x 163 cm (WAF 406)*

ambitious, large-scale history picture that stylizes an event from the year AD 70. At the center of the painting, the high priest, surrounded by his despairing followers, takes his life. In the gloomy background on the left, is the temple in flames, the Wandering Jew, pursued by demons, fleeing from it in terror. Opposite this, Nazarene-like Christians of noble stature march to their death and martyrdom, imbued with the "true faith." Behind them, a Roman conqueror rides into the city. At the top of the painting are the four great prophets lined up in a row, who send out avenging angels. In this way, the dramatic scene is elevated to a God-willed act of judgement. The local colors in the foreground that rapidly decline in intensity, and the smooth, stylized manner of the figure indicate Kaulbach's style here is late Nazarene. He had actually studied under Cornelius at the Düsseldorf Academy. Originally, Kaulbach appended a number of explanations to the picture, which he inserted in the spandrels at the top and which he also issued in printed form. In 1846, the year in which the foundation stone of the former Neue Pinakothek building was laid, King Ludwig I purchased the painting for the enormous sum of 35,000 guilders and determined that it should hang as the central exhibit in the main hall of his new gallery.

Wilhelm von Kaulbach, The Destruction of Jerusalem by the Emperor Titus, *1846, canvas, 585 x 705 cm (WAF 403)*

Karl Theodor von Piloty, Seni before the Body of Wallenstein, *1855, canvas, 312 x 364.5 cm (WAF 770)*

Karl Theodor von Piloty (*b.* Munich, 1826; *d.* Ambach on Lake Starnberg, 1886) was the son of a lithographer from whom he received his initial training. From 1840 on, he studied under Schnorr von Carolsfeld in Munich. Piloty's first major public success was his painting *Seni before the Body of Wallenstein*. Its exquisite style, striking coloration, and narrative manner not only diverted public attention from Kaulbach's complex history paintings, but earned Piloty a professorship at the Munich Academy four years later. Although the painting was praised for its great naturalism, it is difficult to overlook Piloty's dramatic staging of the scene, which is based on Schiller's play *Wallenstein*. The artist condensed various narrative

strands into an expression of inescapable destiny.

The general, who had fought for the Hapsburg Emperor Ferdinand during the Thirty Years' War, had been accused of treason because of his secret peace negotiations with France and Sweden. Seni, the astronomer, had advised Wallenstein to flee during the night. Now Seni stands before the body of his friend like an embodiment of fate. In addition to its eloquent allegorical elements – the burned-out candle in the candlebra, for example, as an image of the extinct flame of life – the picture has a dramatic aura which captures the viewer's attention. At the same time, this is translated into an aesthetic moment of grief. The contrast

between the shadows surrounding the figure of the astrologer and the body of Wallenstein, bathed in radiant light and enveloped in shimmering, pale materials, elevates the general to the status of a heroic victim who has not just been brutally stabbed, but has met his appointed fate.

The Falconer by **Hans Makart** (*b.* Salzburg, 1840; *d.* Vienna, 1884) is an example of the Austrian painter's popular society portraits in which his subjects are attired in historical costume. A somewhat strange aspect of the painting, however, is the striking analogy between the composition and color of the woman and that of the bird of prey on her hand. Not only are both characterized by subdued color and sensuous impasto but by the same reddish tone in the hood of the bird and the ornament in the hair of the woman. Additionally, the subject's physiognomy, with her strangely cool, gray eyes, is echoed in the alert look of the bird. The cold blue background intensifies this impression of watchful, reserved wildness. Reflecting the complex *fin de siècle* image of woman, Makart demonizes his subject here, making her an erotic, alluring, enigmatic – indeed predatory – creature.

Makart studied at first in Vienna and then under Piloty in Munich. He also visited Italy on a number of occasions. Initially fascinated by the drama of Baroque art, he later came to appreciate the balance and

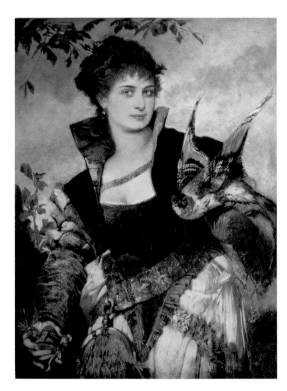

Hans Makart, The Falconer, *c.1880, canvas, 106.3 x 79.9 cm (13291)*

harmony of the Renaissance. From 1879 on, he was a professor at the Vienna Academy, where he led the grand life of an acclaimed painter-prince in the later years of the Austrian Empire.

During the *Gründerzeit*, the period of industrial expansion in Germany after 1871, it was almost a social obligation in Munich to have one's portrait painted by **Franz von Lenbach** (*b.* Schrobenhausen, 1836; *d.* Munich, 1904). Lenbach rose from the rank of a protegé of Count Schack, for whom he made copies of the Old Masters in Italy and later in Spain, to that of a painter-prince who portrayed the cream of Europe's moneyed aristocracy – often on the basis of photos. He lived periodically in Berlin, Vienna, and Munich and, in the 1880s, spent the winter months in Rome. From 1890 on, however, he resided in his stately villa, built in the style of Italian Renaissance, immediately next to the Königsplatz in Munich, where he also had his studio and a gallery. The portrait of *Ignaz von Döllinger* (1799–1890) reveals the brownish, dark "gallery tone", as it was known, inspired by Rembrandt, which became a typical feature of Lenbach's work from the 1870s onwards. The execution and lighting are concentrated on the characterization of the face, and especially the vigilant eyes turned towards the viewer. The opened book the subject is holding in his folded hands is also highlighted. Von Döllinger was a theologian and professor for Roman Catholic Church history on Munich. With his anti-Jesuit stance and his repudia-

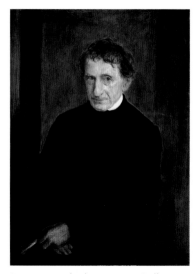

Franz von Lenbach, Ignaz von Döllinger, *1874, panel, 95 x 67.7 cm (7730)*

tion of the new dogma of papal infallability, he provided powerful incentive for the founding of the Old Catholic Church.

A painting like *The Last Reserves* by **Franz von Defregger** (*b.* Stronach, Tyrol, 1835; *d.* Munich, 1921) signalizes the end of the era of ambitious history painting in Munich; for Defregger combines important historical events and popular genre in this scene. The context of the painting is the Tyrolean wars of liberation in 1809 in which the old men of the village have joined forces in revolt against Napoleonic rule. With a few tight groups of figures in the village street – which is strongly foreshortened in perspective and defined by the massive walls of the houses (with no glimpse of the open landscape beyond) – Defregger conveys an impression of an oppressed, but unyielding, rural society united by a

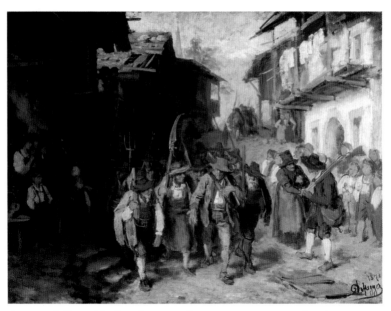

Franz von Defregger, The Last Reserves, *1872, canvas, 53.4 x 70.2 cm (9030)*

fighting spirit. The earthy tones, in which only a few brilliant red and blue spots are allowed as a concession to the colorful local costumes, heighten the rural character of the scene. The picture is a preliminary study for a painting by the same title that hangs in the Austrian Gallery of 19th- and 20th-century art in Vienna. Defregger, who had studied under Piloty, was highly esteemed in society during the *Gründerzeit* as a painter of Tyrolean country life. He was made a professor in Munich in 1878 and was raised to the ranks of the nobility in 1883.

Marées, Böcklin, Feuerbach

Only two years younger than Cézanne, **Hans von Marées** (*b.* Elberfeld, 1837; *d.* Rome, 1887) was a solitary figure whose work inhabits the realm between naturalism and the idealistic mood of his time. After participating in a preparatory class at the Berlin Academy and undergoing a year's training in the studio of Steffeck (a pupil of Gottfried von Schadow and Krüger in Berlin), Marées came to Munich in 1857. His initial paintings there were small-scale naturalistic landscapes and military pictures and portraits which are distinguished by their vigorous, spontaneous brushwork and relatively bright, but restricted palette of grays and browns. Beginning in the 1860s, and influenced by the work of Rembrandt, Rubens, Titian, and Raphael, as well as classical antiquity, with which he had acquainted himself in Rome,von Marées' interest shifted to the portrayal of stately, calm, monumental figures. These works were painted in dark ground tones from which only a few areas of brighter color gleam. An example of this is the glowing orange sphere that recurs in his pictures.

In terms of their narrative content, these figure paintings are an abstraction of the relationship between the sexes, reduced to a formal typology. At the same time, they also describe a distillation of this in the form of a solitary figure who stands above all these attractions and repulsions, and thereby acquires a noble status of a different nature. Thus, they represent the essence of a simple state of human existence. In pictures of this kind, Marées attempts a twofold definition of his own existence: as both an artistic creature and a modern artist. He does this through an artistic language that seems universal and timeless, both formally and contentwise. In this sense, then, his pictorial language is a classical one that is not subject to the narrative requirements of history or the incidental aspects of naturalism. Concealed within his pictorial world is a struggle to achieve an abstract of space that reaches far beyond his time. In this respect, Marées was denied the understanding and public recognition he deserved.

As a copyist of Old Master paintings, he initially enjoyed the patronage of Count Schack, which enabled him to travel to Rome and Florence with Lenbach for the first time. After his break with Schack in 1868, Marées was supported by Conrad Fiedler, a lawyer and philosopher of art. In 1869, Marées traveled with his patron to Spain, France, Belgium, and the Netherlands. Another key figure in the artist's life was the sculptor Adolf von Hildebrand, with whom he painted the frescoes for the zoological institute in Naples in 1873 and with whom he shared a studio in Florence. The

considerable collection of works by Marées in the Neue Pinakothek was the outcome of a donation made by Conrad Fiedler in 1891.

After executing the frescoes in Naples, **Marées** became interested in large-scale, immovable painting. For lack of commissions of this kind, he adopted the large, rhythmically articulated form of the triptych. Among his picture cycles of this type, *The Hesperides* provides perhaps the most striking illustration of his artistic aims, namely to achieve an "absolute" means of representation, here through timeless nudes who express the underlying laws of human existence. Seen in this light, the panels are not a depiction of the events described in the ancient legend, according to which Hercules stole the apples from the Hesperides. In Marees' work, the apples are a gift of the gods guarded by the three sisters in the garden of the gods. Through the intense, concentrated glow of their bodies and their consummate form, the nymphs are elevated to an expression of that higher state of existence to which Marées aspired, and thus are set in a "landscape of yearning" – the "land of the Hesperides," as Marées called it. *The Hesperides* is the only triptych for which the original frame has been retained. Set against a tall plinth in warm Pompeian red, the endearing figures of children can be seen playing with one of the pieces of fruit, which has fallen out of the lofty scene and turned into an orange.

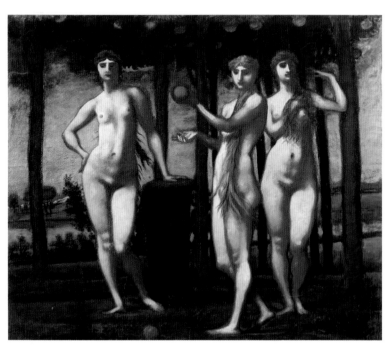

Hans von Marées, The Hesperides, *triptych on panel, 1884–87, central panel 175.5 x 205 cm (7854)*

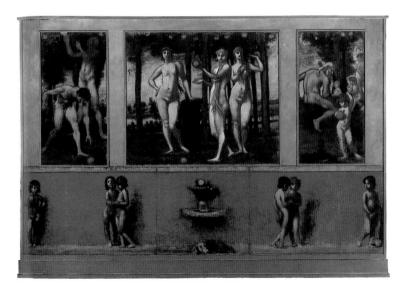

Hans von Marées, The Hesperides, *triptych on panel, 1884–87, wings 175.5 x 88.5 cm each, central panel 175.5 x 205 cm (7854)*

Marées painted his *Diana Resting* in a room in Schleissheim Palace while he was engaged on a commission to execute various decorations for the Russian banker Baron Stieglitz. The subject and composition of the picture, with its splendid setting, luminous nude figure, and radiantly colored background, reveal Marées' interest in the art of Titian, Giorgione, and Rembrandt. Typical of Marées' pictorial concerns here are the reduction and concentration of the picture space into a series of

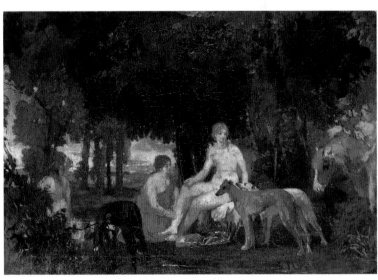

Hans von Marées, Diana Resting, *1863, canvas, 96.2 x 136 cm (7866)*

planar layers and his efforts to achieve an elevated form of representation free of all tension and extraneous effect.

The Three Riders, another triptych by **Marées**, was painted on canvas. In contrast to *The Hesperides*, with its hierarchic gradation of panels, the three sections of this work are all of the same width. The subject matter is different, too. It is not based on classical myth, but on Christian legend, with portrayals of three figures who subsequently became saints. The painting on the left depicts the Roman soldier Martin, who divided his cloak to share it with a beggar. The central scene shows Hubert, the hunter who mended his ways and entered a cloister, having seen the Divine in the form of a stag during a hunt. On the right, is a painting of the soldier George, this knightly fig-ure, mounted on a rearing horse, energy-laden, and full of fighting spirit. The depiction culminates at the top in a flame-like plume and may be regarded to some extent as a portrayal of Marées himself. *The Three Riders*, organically integrated into a triptych in the manner of classical antiquity, also represents a typology of human characters, each on a different path to divinity.

In *Self-Portrait with a Paintbrush*, the final likeness he painted of himself, **Marées** faces the viewer in an erect, upright position. In this pose, he not only asserts his status as an artist, but provides the viewer with an account of himself and of his art. In other words, here is a unique, existential man, whose sensitive features suggest that he possesses a detached maturity that belies his true age. Marées was forty-six years

Hans von Marées,
Self-Portrait with a
Paintbrush, *1883,*
panel, 99.5 x 64 cm
(7868)

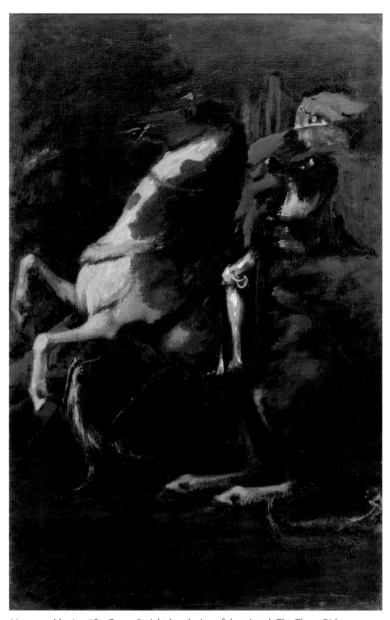

Hans von Marées, "St. George", right-hand wing of the triptych The Three Riders, *1885–87, canvas, 183 x 117 cm (7858)*

old at the time and was never to attain the ripe old age the work suggests. The portrait was painted in conjunction with an exhibition of his works planned for the autumn of 1883 in Berlin, but which never came to be. On April 28, 1883, he wrote to Conrad Fiedler: "To authenticate the pictures as creations of our time, so to speak, I have added a life-size, half-length portrait of myself."

Adolf von Hildebrand (*b.* Marburg, 1847; *d.* Munich, 1921) made the acquaintance of Marées and Fiedler in 1867 on a journey to Italy, which he undertook with his teacher Kaspar von Zumbusch. In 1869, Hildebrand met the pair again in Berlin. In 1872, he left for a longer stay in Italy. The following year, he and Marées executed the decorations in the library of Anton Dohrn's zoological institute in Naples. In the same year, Hildebrand had his first great success at the World Exhibition in Vienna, and, in 1874, he purchased the deserted monastery of San Francesco in Florence, where he worked with Marées for a year. *The Net Bearer* is characterized by a spiralling movement; a figure balancing the loads beneath the net

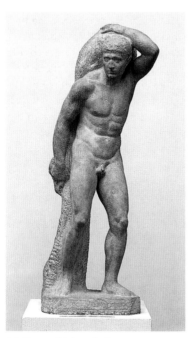

Adolf von Hildebrand, The Net Bearer, *1886, marble, h. 145.5 cm (B.367)*

establishes a state of equilibrium. The clarity and beauty of his head and body are articulated through a series of shifting accents. The figure, which is not fully elaborated, was first executed in 1886, some ten years after the friends had parted company. Nevertheless, it seems like a precisely worked, sculptural materialization of one of those timeless nude figures that Hans von Marées depicted in his paintings.

Adolf von Hildebrand sculpted the *Bust of Conrad Fiedler* between 1874–75, the period he worked with Hans von Marées. Fiedler (1841–1895) had studied law, but because he was the son of an industrialist, he was able to pursue his interest in art. He was friends with numerous artists, including Feuerbach, Hildebrand, and Marées. The work of Marées in particular made a deep impression on him, and throughout his life Fiedler vigorously supported his cause. Fiedler was also a well-known philosopher of art, who published his views in works such as *Über die Beurteilung von Werken bildender Kunst* (1876) and *Über den Ursprung der künstlerischen Tätigkeit* (1887). Fiedler rejected the traditional approach to art history of his time, whereby works were categorized according to various styles. He sought a more subjective perception of art: "One striking phenomenon, on the other hand, is that modern art historians betray not the slightest doubt as to whether they really understand a particular work of art ... and that is the most pernicious outcome of this new trend: it suggests a famil-

Anselm Feuerbach, Medea, *1870, canvas, 197 x 395 cm (9826)*

iarity with works of art and obscures the fact that the works remain completely uncomprehended despite this familiarity."

Like Marées, the painters Arnold Böcklin and Anselm Feuerbach found in Italy, and especially in Rome, congenial surroundings that provided them with new impulses for their work – despite the fact that France was increasingly becoming the centre of modern developments in art. For these painters, Italy, with its many different peoples and types, its southern flavour and culture, was a country both of classical antiquity and of an ideal, beautiful art that transcended the vagaries of modernism.

Anselm Feuerbach (*b.* Speyer, 1829; *d.* Venice, 1880) studied under Wilhelm von Schadow at the Düsseldorf Academy before traveling to Munich, Antwerp, Paris, and finally Rome, where he stayed from 1855 to 1872. Feuerbach increasingly sought an artistic language that was free of extraneous content and that would culminate in the expression of lofty ideas. It was to mani-

fest itself in sublime, monumental figures of a sculptural quality, caught in a state of melancholy. Feuerbach was inspired to paint the mythological figure of Medea after seeing Ernest Legouvé's drama in Rome in 1866. The daughter of a king, Medea was versed in the arts of magic, and she assisted Jason and the Argonauts in obtaining the Golden Fleece. In his painting of *Medea,* Feuerbach distils the complex and highly dramatic character of the princess into a symbol of ineluctable, tragic fate. On the right of the picture, (on a rugged, remote shore) the Argonauts' ship prepares to sail. On the left is Medea, and her two children by Jason. The two groups are separated by a mourning figure, a symbol of Medea's future madness, brought about by her grief at the loss of Jason, and her murder of her children.

Arnold Böcklin (*b.* Balse, 1827; *d.* Fiesole, 1901) represents a quite different aspect of the yearning for the ideal expressed by Feuerbach. The fabulous creatures, gods, and

shepherds in Böcklin's pictures entice the viewer into a lusty world of classical nature pervaded by pantheistic elements. A painting like *Pan among the Reeds*, therefore, conveys an immediate sense of the melancholy and solitude of the south at the hottest time of day. This is a time when everything stands still, a time apart, made manifest in the figure of Pan, the lecherous chaser of nymphs, whose favorite time to pursue of his pleasures is midday. On this occasion, however, this demon of nature has only his syrinx on which to play, and he would seem to sound a melancholy tune. The strikingly atmospheric quality of the painting is achieved through the restriction of the picture detail and by making the sole plant form in this scene

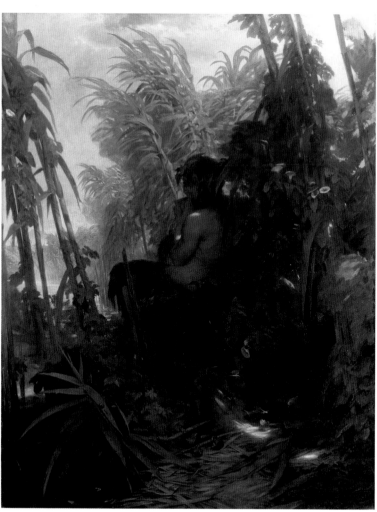

Arnold Böcklin, Pan among the Reeds, *1859, canvas, 199.7 x 152.6 cm (WAF 67)*

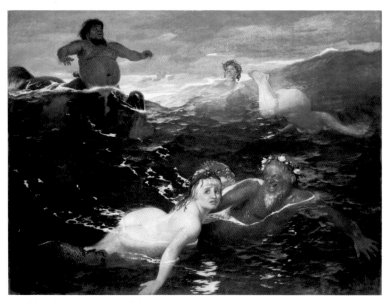

Arnold Böcklin, In the Play of the Waves, *1883, canvas, 180.3 x 237.5 cm (7754)*

the dominant pictorial element. The figure of Pan merges into the vegetation, drawing the observer into the thicket of reeds.

In the Play of the Waves vitality is elevated to the level of eroticism with humorous undertones. The painting was inspired by an experience Böcklin had while bathing with the family of Anton Dohrn, for whose zoological institute in Naples Hans von Marées and Adolf von Hildebrand had painted frescoes in 1873. Dohrn, portrayed here in the figure of Triton, apparently took great pleasure in suddenly surfacing from beneath the waves and frightening the ladies. Here again, Böcklin draws the viewer into the events of the picture by evocatively suggesting the swell of the sea. He achieves this, as in his painting of *Pan among the Reeds*, by restricting the pictorial detail and by placing

the human figures on a par with the natural forms, which dominate the work.

Böcklin studied in Düsseldorf under Schirmer before going to Geneva and Paris, where he witnessed the June revolution. In 1850, on the advice of Jacob Burckhardt, he traveled to Rome. He made friends with Anselm Feuerbach and, like him and Marées, enjoyed the patronage of Count Schack for a time.

Like Böcklin, **Hans Thoma** (*b*. Bernau, Black Forest, 1839; *d*. Karlsruhe, 1924) studied landscape painting under Schirmer. A journey to Paris in 1868 afforded him a profound insight into the work of Courbet, the Barbizon School, and Millet. In Munich, the paintings by Wilhelm Leibl and his circle were also influential to his development.

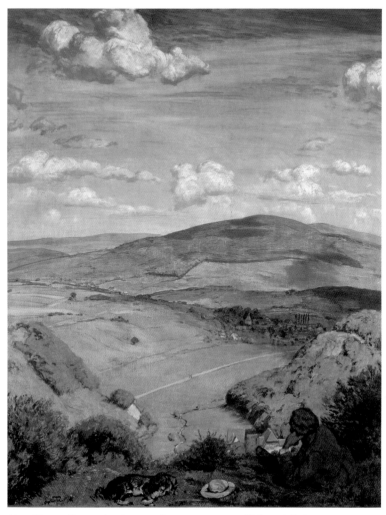

Hans Thoma, Taunus Landscape, *1890, canvas, 113.3 x 88.8 cm (7834)*

Thoma's *Taunus Landscape* is a broad, objective view that is delightfully sublimated by its densely woven continuum of pale-green and blue tones. A contemplative wayfarer resting in the foreground may be seen as a reminiscence of the Romantic age.

Wilhelm Leibl and His Circle

Wilhelm Leibl (*b*. Cologne, 1844; *d*. Würzburg, 1900) studied from 1863 to 1869 at the Munich Academy, where he soon made friends with the painters Hirth du Frênes, Theodor Alt, Johann Sperl, and Fritz Schider. As the strongest artistic personality in the group, Leibl became the leading figure in this circle, which was joined a short time later by Wilhelm Trübner and Carl Schuch. The group soon formulated its opposition to the history painting of artists such as Kaulbach and Piloty, the two leading figures at the Munich Academy at that time. The younger artists were interested in an intrinsic realism, based on a serious and objective view of the world, in which pictorial form would no longer be subservient to content, but where form and content would enhance each other. In this respect, the artists recognized a debt to 17th-century Dutch and Flemish painting as well as to Courbet and the Barbizon School. Leibl's first major success was his *Portrait of Mina Gedon*, which caused a sensation in Munich and Paris. Despite his success in Paris, however, Leibl withdrew to the peace of his Munich studio to concentrate on his work; in 1873, he moved from the bustle of the city to the country. Working in various villages and hamlets, he devoted himself to the portrayal of rural, farming people, occasionally in genre-like settings. Alongside this, he continued to explore the theme of formal portraiture. Wilhelm Leibl's artistic aim was to create an objective representation of man. He achieved this with a restricted range of rich but, subtle tonal values and by seeking to capture the intrinsic nature of his subjects rather than some three-dimensional quality or palpably sensuous presence. In this context, Leibl wrote of "my art, which may not be touched by the slightest trace of fraud or charlatanism" (letter to his mother, 1878).

Leibl painted the *Portrait of Mina Gedon* when he was twenty-five years old, his eye set ambitiously on the 1st International Exhibition of Art, which was held in the Crystal Palace in Munich in 1869. He received the acclaim of his fellow artists, but not the gold medal for which he had hoped. Courbet, who was represented at the exhibition with his own works, including his famous *Stonebreakers*, praised Leibl's portrait as the impressive highlight of the event. Before long, Courbet was on friendly terms with Leibl and his circle. It was Courbet who advised the painter to go to Paris and who organized an invitation to that city with the help of wealthy patrons of the arts. Leibl received enormous acclaim in Paris for this painting and won the gold medal at the Salon of 1870. This portrait of the wife of the

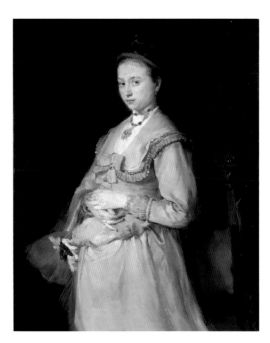

Wilhelm Leibl, Portrait of Mina Gedon, *1869, canvas, 119.5 x 95.7 cm (8708)*

Munich architect and sculptor Lorenz Gedon is a captivating, powerful and yet intuitive characterization of the young, pregnant woman. An important aspect of the portrait is that Gedon's social standing is reflected in her attire and jewelry. Also stressed are her questioning look, natural facial expression, and maternally protective hands. In this way, Leiexpressed by Feuerbach. The fabulous creatures, gods, and shepherds in Böcklin's pictures entice the viewer into a lusty world of classical nature pervaded by pantheistic elements. A painting like Pan among the Reeds, therefore, conveys an immediate sense of the melancholy and solitude of the south at the hottest time of day. This is a time when everything stands still, a time apart, made manifest in the figure of Pan, the lecherous chaser of nymphs, whose *favorite time to* pursue of his pleasures is midday.s a much greater distance and abbreviated, fragile presence. In three-dimensional terms, the figure is comprehensible only in outline, and hovers between the act of turning into the light and withdrawing into the dark background. Only her face and hands are contrasted with the cool gray and black tones and articulated with light, which is here cold and clear. The red of her cheeks and mouth, together with the coral necklace and its gently swinging pendant, add a sense of life and movement. The figure, painted with concise, rapid brushstrokes, appears lighter and more fleeting than that in the *Portrait of Mina Gedon,* but also more firmly bound into the painting's surface. The dif-

Wilhelm Leibl, Portrait of Lina Kirchdorfer, *1871, canvas, 111 x 83.5 cm (8446)*

ferences between the two reflect Leibl's study of contemporary portrait painting during his visit to

Wilhelm Leibl, The Girl with a White Headscarf, *c.1876, panel, 21.5 x 17 cm (9402)*

Paris. In his use of a predominantly gray palette and in the characteristic isolation of the figure, he might be identified with Manet. But Leibl was pursuing a quite different idea in this portrait. He did not seek to portray a mature woman in a state of repose but, rather, a still demure and somewhat uncertain young girl.

In pictures such as *The Girl with a White Headscarf*, Leibl achieves a concise, simple form of portraiture – both formally and in terms of content. The young woman's head fills the entire panel and is presented in a manner that deliberately suggests a detail from a larger whole. Her face emerges from large, independent planes – the white headscarf, on the one hand,

and the bright background on the other. As a result, everything is concentrated on what appears to be the girl's sidelong glance at something moving in the opposite direction. Her expression suggests suspicion and lack of distance to the unknown observer. The brightness of Leibl's palette and the cropped picture detail may be seen as Leibl's response to the achievements of contemporary French painting. On the other hand, the wood panel on which the picture is executed and the stiffness and sharp contours of the girl's face reveal Leibl's great interest in Old Master painting, a phenomenon that reaches its climax in his *Three Women in a Village Church* (in the Kunsthalle, Hamburg).

Wilhelm Trübner (*b.* Heidelberg, 1851; *d.* Karlsruhe, 1917) painted *In the Studio* in 1872, in which the two figures are engaged in conversation. The woman, who is seated in an armchair, her head turned to one side and partially concealed behind her fan, addresses a man, whose profile is completely shaded by a broad-rimmed hat. The painting reveals a subtle interplay of proximity and distance that envelops both figures in an aura of intimacy, removing them from the reach of the viewer. Trübner creates remarkable contrast between an intangible, carefully balanced pictorial world and the real world of the cigarette tossed carelessly to the ground. With its restricted palette of closely related brown, gray

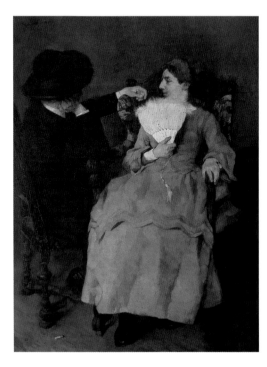

Wilhelm Trübner,
In the Studio, *1872, canvas,*
82 x 61 cm (8108)

Rudolph Hirth du Frênes,
Portrait of the Painter
Carl Schuch, *1874, canvas,*
69 x 50.3 cm (7835)

and black tones, the painting is an outstanding example of the so-called Munich valeur painting of this period. After studying in Karlsruhe and Stuttgart, Trübner returned to Munich in 1870 where he joined the circle of painters associated with Leibl.

The *Portrait of the Painter Carl Schuch* by **Rudolph Hirth du Frênes** (*b.* Gräfentonna, Thuringia, 1846; *d.* Miltenberg am Main, 1916) is an example of the portrayals of friends that were popular in the Leibl circle. Leibl also painted a likeness of Schuch in 1876, which hangs in the same room. A striking feature of the portrait by Hirth du Frênes is the chiaroscuro with which the head of his friend and fellow paint-

er is articulated. Schuch emerges, fuzzily yet vividly from the darkness, as if captured in passing – a momentary characterization, spontaneously illuminated and sceptically aloof. Schuch's head appears to merge with the extremely dark background, for which a much softer range of tonal values was used than in Trübner's *In the Studio.* Hirth du Frênes joined the Leibl circle in 1869 and soon after worked together with Leibl, Sperl, and Alt in a studio in Arcisstrasse in Munich.

After Leibl and Trübner, **Carl Schuch** (*b.* Vienna, 1846; *d.* Vienna, 1903) was the most important figure in the circle of painters around Leibl. He studied from 1865 to 1869 in Vienna. In 1871, after a stay

Carl Schuch, Peonies, *c.1885, canvas, 67.5 x 56 cm (8599)*

in Italy, he made the acquaintance of Leibl through Trübner. Further journeys took Schuch to Belgium, the Netherlands, Italy, and France, with longer stays in Venice and Paris. His still life with *Peonies* demonstrates his preference for calm arrangements restricted to only a few objects. At the same time, it is also a fine example of the masterly way in which Schuch increasingly separated style from the description of the subject. Despite the sparkling fullness of life the painting, the color and lighting values, contrasted with a brownish ground, reveal an earlier style in which a restricted palette was used. Thus, Schuch can be seen to have achieved an extremely personal development of French Impressionism.

Impressionism

Impressionism was not a movement that spontaneously manifested itself in the middle of the 19th century. The movement was a fusion of various tendencies and streams of non-academic realism that had existed since 1800. Important harbingers of this movement can be seen in a number of artistic developments: in the *plein-air* painting of the Barbizon School, with its direct observation and its simple, unassuming manner of depicting nature and human beings; in Courbet's realist pictorial language; and in the transparent atmospheres found in English landscape painting, especially in the work of Constable. An equally important influence was the vivid coloration of Delacroix, which, as a result of his study of the Venetians and Rubens, was purged of the earthy tones promoted by the academies. Colored Japanese woodcuts, which became increasingly widespread from the 1860s on, also played a role that should not be underestimated in this context. The woodcuts usually depicted brief details from everyday life, but they also contained abrupt juxtapositions between areas of color, and exciting contrasts between detailed and plain surfaces. The increasing importance of the natural sciences and the empirical methods of observation they introduced – which Emile Zola compared with the precise observation and unbiased representation of the artist – were a further important aspect in the development of this movement.

Impressionism, therefore, is distinguished by a new approach to reality. Attention was no longer focused on details and a painstaking narrative description, but on capturing an immediate pictorial impression of a subject. Fleeting visual attractions were created when bright, bold masses of color juxtaposed with each other and applied to a canvas with a white, instead of a brown, ground. In short, the Impressionists were concerned with an objective depiction of everyday sensations and phenomena, preferably in a *plein-air* form of painting. The affirmation of their own time – *être de son temps* – became their guiding principle. Invention, storytelling, and sentiment were rejected. Rather, the Impressionists drew their themes from quite different realms: the bustle of the modern city with its various public stages – the boulevards, restaurants, theatres, and revues – the intimacy of middle-class private life, and the unencumbered serenity of cultivated nature, which offered a place of recuperation from city life and a liberation from bourgeois rules and regulations. The name of this avant-garde movement was taken from a painting by Monet: *Impression, soleil levant* (1872), which depicts a harbor in the morning

mist. Coined in 1874, the term was initially meant to ridicule and to demonstrate the artistic incompetence of a group of thirty artists who had exhibited their works in Nadar's photographic studio. Among this group were Monet, Renoir, Sisley, Degas, Morisot, Pissarro, and Cézanne.

The so-called German Impressionists, in particular Liebermann, Slevogt, and Corinth, were influenced by the brightly-colored, light pictorial language of the French avant-garde without pursuing the same goals. In Germany, there was less emphasis on the use of translucent areas of paint, in which form and space dissolve, than on a clarified, brighter, and animated kind of painting, with a limited palette. The sense of space, the selected picture detail, the volumetric form and its material depiction were not entirely abandoned. Yet, on the whole, German Impressionism remains heavi-

er, more subdued, and strongly oriented to the object, especially its content, than is the case in France. The use everyday subjects is found equally in *plein-air* painting as in the depiction of the rural world of farming people. Only later is the subject matter broadened to include the urban middle and working classes, often combined with socially affirmative elements.

French Impressionism

Claude Monet (*b*. Paris, 1840; *d*. Giverny, Seine, 1926) became the leading figure in the new *plein-air* painting movement. He spent his childhood in Le Havre, where he worked with Boudin and Jongkind for a time. In Paris, he studied with Pissarro at the Académie Suisse and at the same time briefly attended the Atelier Gleyres, where he made friends with Sisley, Renoir,

Claude Monet, Bridge over the Seine at Argenteuil, *1874, canvas, 60 x 81.3 cm (8642)*

and Bazille. Before long, Monet was propounding that artists paint their scenes exclusively from life and the outdoors. For this purpose, he used a small boat fitted with painting supplies and from which he could more immediately observe the changing mood of the light over the water. The *Bridge over the Seine at Argenteuil* was painted in 1874, in the year of the first exhibition of Impressionist work. Swiftly executed, for the most part with considerably thinned paint, the painting is distinguished by light, open brushwork, which helps to blend the ungrounded gray canvas with the colorful pictorial impression on its surface. Monet's attention is focused on the mood created by light, which is determined equally by the moving surface of the river and by the sky. All of the forms are subordinated to the light, including the figures bending over the railing of the bridge at the top of the picture, who are reduced to no more than sketchy secondary elements. The broad arches of the modern bridge, erected in 1872, establish the scale of the composition. They form a supporting framework for the fluid colors and establish a rhythm that suggests the continuation of this scene beyond the edges of the painting.

The Boat by **Edouard Manet** (*b*. Paris, 1832; *d*. Paris, 1883) was also painted the year of the first exhibition of Impressionist art, during his stay in Argenteuil with Monet, where the latter lived for five years after the Franco-Prussian War. In the bright, bold palette and the light, terse brushwork of this painting, Manet demonstrates that he was receptive to his friend's spon-

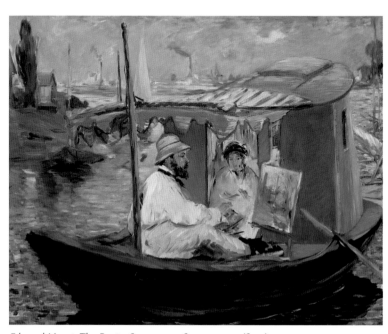

Edouard Manet, The Boat, *1874, canvas, 82.5 x 105 cm (8579)*

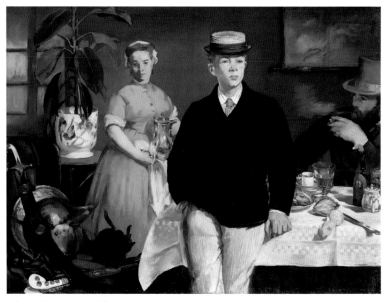

Edouard Manet, Breakfast in the Studio, *1868, canvas, 118 x 154 cm (8638)*

taneous style of painting. Particularly in his depiction of the water surface, Manet loosely juxtaposes patches of color – chromatically graduated in some areas and contrasted in others. In Manet's case, however, the colors are generally less integrated than in Monet's *Bridge over the Seine.* The contrasts are bolder, and the forms are more consolidated. Above all, Manet sets the human figure at the center of his painting, placing emphasis on his friend, whom he observes painting, and Monet's wife seated behind him in the boat.

Manet's main preoccupation was the portrayal of human beings. The image of man was of central importance in his detailed studies of the major Old Masters of Dutch and Italian painting and of the painters who were the "new stars" at that time: the Spaniards Velázquez and Goya. In the overall impression it conveys, Manet's painting *Breakfast in the Studio* is fascinating because of its calmness, beauty, and richly varied material qualities. Nevertheless, the painting is disconcerting because of the disparity of its individual elements. These the painter juxtaposes and mingles in the nature of a still life in which attention is paid to the precious surface luster of the objects, while combining them with vaguely defined, two-dimensional areas of color. As a result, the location remains uncertain: Is it a domestic living room or a studio? One thing is clear, however, Manet used various studio props – from the helmet to the finely peeled lemon – to decorate the scene, even though these objects do not fit into the sequence of a meal. How can coffee be served when the oyster hors d'oeuvres are still on the table?

The lack of homogeneousness is even more apparent in the three figures. Although their eyes appear to move in different directions, each seems as if tranfixed. The strange mixture of artificiality and naturalness of this painting reflects Manet's evident preoccupation with questions of illusion and perception. Above all, though, in the emphasis he places on isolation and alienation – as far as time, place and the contact between the figures are concerned – he takes a fresh and topical look at his contemporaries.

Edgar Degas (*b*. Paris, 1834; *d*. Paris, 1917) was the son of a banker and raised in an upper-class environment. Like Manet, who was the son of a wealthy civil servant, he was free of material worries throughout his life. After briefly studying law, Degas received tuition in painting and drawing and studied for two years under pupils of Ingres at the Ecole des Beaux-Arts. His meeting with the 75-year-old Ingres in 1855 had a formative influence on his entire creative life. Ingres recommended that he "draw lines ... lots of lines, whether from memory or from nature." From 1862 on, Degas was a friend of Manet and also made the acquaintance of the Impressionists. He took part in their exhibitions, but did not adopt their bright palette or accept the primacy of *plein-air* painting. He was concerned above all with the human figure and its spontaneous movements. In addition, he showed a strong interest in the lighting effects that had become possible with the introduction of artificial illumination. From the

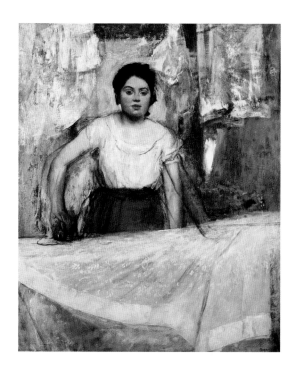

Edgar Degas,
Woman Ironing,
c.1869, 92.5 x 74 cm
(14310)

1880s on, he suffered from an eye ailment which became progressively worse, until in 1910, he was no longer able to work.

Degas was also an art collector on a grand scale who acquired not only the works of his contemporaries, but Old Master paintings as well.

Woman Ironing is an early example of Degas's lifelong interest in unspectacular, everyday female chores. This may be seen in his depictions of washing women, weary ballerinas, hat-makers and prostitutes. The *Woman Ironing* is one of the first of this long line of female figures. A simple, somewhat buxom young woman, she is portrayed in an unassuming frontal pose, her sleepy, swollen eyes turned to the viewer, who is kept at a distance by the ironing board. Likewise, the viewer is not distracted from the intensity of the woman's ordinary appearance by the kind of spatial elaboration that was to be of central interest to Degas in his later career. The evident changes he made to the position of the woman's arms – contrasted with the compact articulation of her firm young face, which is reminiscent of Ingres – are an indication that Degas did not complete this picture. This is substantiated by the contrast between the gauzy material, worked with a pattern of leaves, on the ironing board before her and the rough, sketchy depiction of the laundry hanging behind her. This tension between planar, open forms and three-dimensional closed forms, together with the shimmering gray-blue colors, from which only the red of the lips and the eyelids stands out, lends this figure its special fascination and ambivalent physical presence.

Over the course of the 1880s, pastel became an increasingly important expressive medium for Degas. The technique, used in a new, open form of application, was ideally suited to his manner of depiction, with its radical formal reduction, gradual abandonment of fully elaborated details, and a growing sketchiness and incompleteness.

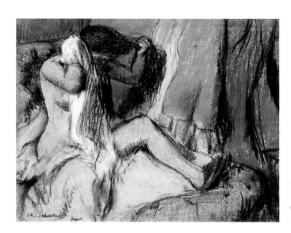

Edgar Degas, After the Bath, *c.1888–92, pastel on paper, 48 x 63 cm (13136)*

After the Bath, executed at the end of the 1880s, affords viewers a view of a woman who is totally engrossed in her private toilet. The painting's confined composition accentuates both the three-dimensional quality of the figure – articulated with only a few brief but bold lines and limited areas of shading – and the restricted range of warm pink and yellow tones that signify the female realm. The motif and the pastel technique result in a strangely contradictory effect: the rough crayon surface removes any sense of voyeurist titillation from this intimate view.

Degas modeled a number of small maquettes in wax – three-dimensional studies with which he sought to clarify questions of balance, the distribution of mass in the movements of figures, and the plausibility of a particular pose. This group of works includes the *Dancer*, a heavy but compact female figure, the surface texture of which indicates the original modelling material. Around 1900, Degas had a number of these three-dimensional studies cast in plaster and later in wax. After his death, twenty-two more castings were made by the founder Hébrard at the commission of the artist's family.

The *Portrait of Henri Rouart and His Son Alexis* is one of the few late oil paintings Degas executed. It is fascinating because of its lack of logical space; the two male figures have scarcely any physical presence, seeming to float schematically against the yellow picture ground. The seated figure, of which only the upper part is shown, seems in danger of slipping out of the painting because of its emaciated state. In striking contrast to this, is a tall, slender figure which conveys an impression of agility and businesslike purpose. Degas, who was extremely short-sighted by the time he painted this picture, but he was so familiar with the family of his former schoolmate Henri Rouart from a friendship extending over many decades, and from the many portraits he had painted of members of this family, that he knew his subjects almost by heart. Here, he transforms the double portrait of father and son into an allegory of life in which the limitations of old age are painfully set alongside an expression of youth. The unusual coloration of this pic-

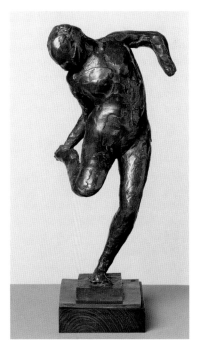

Edgar Degas, Dancer, *c.1890–1900, bronze, h. 45 cm (B.134)*

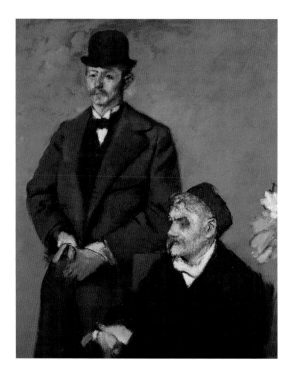

ture, its restraint and reduction to a few yellow, brown and gray tones, is reminiscent of the pastel technique favored by Degas.

Like Monet and Sisley, **Camille Pissarro** (*b.* Saint-Thomas, Danish Antilles, 1830; *d.* Paris, 1903) escaped the Franco-Prussian War by moving to England. There he painted the *Street in Upper Norwood*, the London suburb where he lived. The diagonal line of the street and the sketchy, unclear figures – people in the moving carriage, girls hurrying in the opposite direction, and a rider who is about to disappear from the field of view – lend the scene a dynamic sense of movement. The dull, oppressive mood of this day in late winter is echoed by the crowded rowhouses

and their detailed depiction as well as by the subdued, grayish color reminiscent of Corot. All these elements are expressly described by the painter in the original title he gave this work: *Route de Upper Norwood, avec voiture; temps gris.* It is a melancholy painting that expresses a yearning for the expansiveness, warmth, and colorful life of France.

Pissarro studied at the Académie Suisse, where he made the acquaintance of Monet, Guillaumin, and Cézanne. In 1863, he exhibited his work together with Manet, Cézanne, Fantin-Latour, and Guillaumin in the salon of "rejected" artists. He was the only painter to participate in all eight Impressionist exhibitions. From 1866 on, he worked in Pontoise, where he

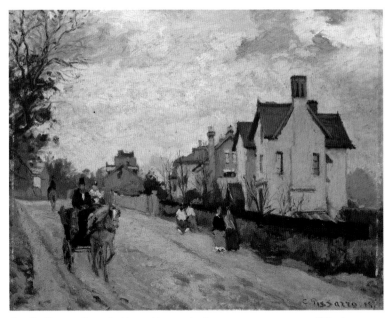

Camille Pissarro, Street in Upper Norwood, *1871, canvas, 45.3 x 55.5 cm (8699)*

moved permanently with Cézanne in 1872. In the intervening period, he also worked in Brittany and in London, where he studied the work of Turner and Constable.

Alfred Sisley (*b.* Paris, 1839; *d.* Moiret-sur-Loing, 1899) was the son of an English businessman and a French woman. After receiving commercial training in England, he

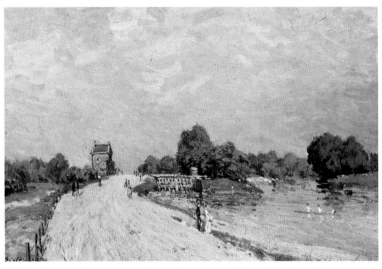

Alfred Sisley, Road in Hampton Court, *1874, canvas, 38.8 x 55.8 cm (13134)*

studied, like Monet, Renoir, and Bazille, in the studio of Gleyre. In 1874, he traveled to England again, where he painted the *Road in Hampton Court*. The picture exhibits none of the melancholy evoked by the dreary English climate, as in the case of Pissarro. Here, the broad, pleasant landscape merges with the lovely, pastel-like atmosphere of shimmering summer sunlight in which water and sky are transformed into mirror-like surfaces.

In his *Landscape in the South of France*, **Auguste Renoir** (*b.* Limoges, 1841; *d.* Cagnes-sur-Mer, 1919) invites the viewer to immerse his eye in the depths of the luxuriant southern vegetation. The almost tropical profusion and fertility of the scene, into which the clear blue sky creeps only at the edges, was achieved by means of a dense impasto (layering of paint on the canvas) – applied partly with brief dabs of the brush, partly with linear strokes – and by the sensuousness of the richly verdant landscape flushed with red tones. Along with Monet, Renoir was the leading figure among the Impressionists. He was trained as a porcelain painter and worked initially as a decorative artist. In 1862, he attended the Ecole des Beaux-Arts for a year. He then moved to Gleyre's studio, where he met Pissarro, Monet, Sisley, and Bazille. Between 1869 and 1874, he worked on a number of occasions with Monet.

Auguste Renoir, Landscape in the South of France, *c.1890, canvas, 53.7 x 65.3 cm (14217)*

Auguste Renoir, Young Woman in Black, *1876, canvas, 60.5 x 40.5 cm (8644)*

Renoir's *Young Woman in Black* is striking because of its pastel-like, soft femininity. The articulation of the individual features of the woman is not as important as the impression created by two phenomena: the delightful interplay between light, superficial brushwork to suggest a state of weightlessness on the one hand and restrained color, reduced to a balance between bright and dark shades on the other. The careful elaboration of delicate skin tones drawn from the black of the dress together with those taken from picture ground harmonizes in their brightness and testify to Renoir's subtle painting technique. The main highlight in the depiction of this sensuous, relaxed woman is fresh bright red lips.

Aristide Maillol (*b.* Banyuls-sur-Mer, 1861; *d.* Banyuls-sur-Mer, 1941), the son of a Catalan cloth merchant, came to Paris at the beginning of the 1880s. He applied for admission to the Ecole des Beaux-Arts and at the same time attended the Ecole des Arts Décoratifs. In the mid-1890s, Maillol, who also worked in the field of arts and crafts, decided to devote himself to sculpture. The *Bust of Auguste Renoir* was executed at the request of the painter, who had long been interested in Maillol's

Aristide Maillol, Bust of Auguste Renoir, *1907, terracotta, h. 38.5 cm (B.59)*

work. (A central theme in the work of both artists was the depiction of sensual beauty and natural harmony of the female figure. Maillol portrays Renoir at the age of sixty-seven, lean-faced, with sunken cheeks, a pointed, protruding nose, and a goatee beard, as if marked by age and illness. Yet, the sharp-featured, striking profile and alert, lively eyes beneath the narrow brim of the hat – originally a white linen hat that Renoir wore when painting outdoors – counteract the impression of old age and decline. This observation is confirmed by Renoir's continued painting activity at the time, although he had suffered from such severe rheumatism since the turn of the century that his hands began to be crippled and he was forced to return to the warmth of

the south of France. The terracotta bust formed the model for subsequent castings in bronze.

Paul Cézanne (*b.* Aix-en-Provence, 1839; *d.* Aix-en-Provence, 1906) was the son of a banker from Aix. He abandoned his law studies to attend the Académie Suisse, where he made the acquaintance of Monet, Sisley, Pissarro, and Renoir. Initially, his pictorial world was heavy and dark, full of emotions and brutality. Later, he moved away from this style and discovered a certain affinity with Impressionist painting.

Only on one occasion, however, in 1874, did he take part in an Impressionist exhibition, which caused Manet to cancel his own participation. From 1872 to 1874, Cézanne worked with Pissarro in Auvers and Pontoise, during which time he developed a lighter, more fluid patch-like application of paint. Ultimately, however, he sought his own, personal form of artistic expression, which had nothing in common with Impressionist spontaneity and the absence of a spatial-volumetric dimension.

Cézanne struggled to achieve a clearly structured natural form of representation that was volumetric and firmly integrated into the picture plane. His forms were condensed to their essential nature and thereby to acquired a timeless quality. His artistic language, which attached greater importance to veracity than to "correct draughtsmanship," was to pave the way for Cubism and, in particular, for Picasso. Among his contemporaries, however, Cézanne found little understanding.

Paul Cézanne, The Railway Cutting, *c.1870, canvas, 80 x 129 cm (8646)*

The Railway Cutting, painted probably around 1870 near the "Jas de Bouffan," the country house of Cézanne's father in the Arc valley, is the first painting in which the Montagne Ste. Victoire appears. This powerful, looming mountain dominates the plain east of Aix-en-Provence. Cézanne divides this excerpt of the landscape into two realms: that of human beings in the foreground, (with its modest house

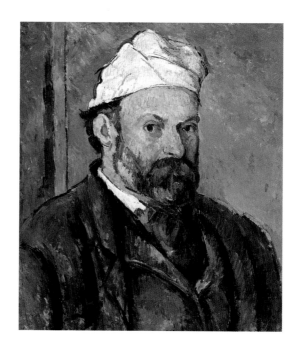

Paul Cézanne,
Self-Portrait, *c.1880,*
canvas, 55.5 x 46 cm
(8648)

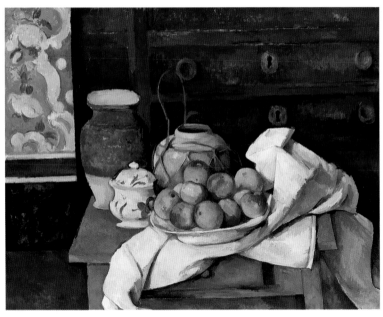

Paul Cézanne, Still Life with Chest of Drawers, *c.1885, canvas, 73 x 92 cm (8647)*

and subdued, earthy color) and that of the mountain in the distance, removed from the human world. Painted in bright blue tones and with lively brushwork, the mountain is juxtaposed against the light, clear sky. The two worlds of the picture are separated by a railway cutting, depicted as a sharp, painful and insurmountable incision in nature.

Cézanne's *Self-Portrait* is both a description and exploration of himself. The artist becomes the interpreter and observer of himself in one. His portrait acquires weight and proximity through the block-like massiveness of his body, which appears erect and taut because of parallel shadow lines. The narrow strip of wood on the wall behind him ties his figure firmly into the picture plane. The lighter areas of

his face, half-concealed by a thick beard, and his turban-like head covering, suggest a sense of aloofness and immateriality, as does his gaze, which extends to a point beyond the viewer. The brightness and unconventional form of his head covering accentuate conflicting character, lending him the attributes of both a bourgeois person and an inaccessible spiritual being. The *Still Life with Chest of Drawers*, painted in the mid-1880s, presents the third main genre Cézanne explored in his work, besides landscape and the human image. The striking aspects of this picture are its balance, composition, color, and equality of three-dimensional form and planar surface. Of the few clearly articulated volumetric elements, the sphere-like apples predominate, echoed by the bulging

shapes of the pots and vases. Contrasted with this are the sharp folds of the tablecloth, half pushed aside, and the hard edges of the table itself, which are reflected in the simple verticals and horizontals of the chest of drawers. The color, too, is confined to a tight spectrum, ranging from the warm reds and yellows of the fruit, which reverberate in the brown of the chest of drawers, to the cold tones of the tablecloth. Cézanne is rigorous in his arrangement of objects and highly sensitive to colors and forms; with an unerring eye, he abstracts the time of day and changing lighting effects. Here again, he attempts to impose a fundamental order and balance on the various objects, even if he repeatedly does so by setting three-dimensional form in relation to planar surface, thus making his artistic parameters the subject of the painting.

Vincent van Gogh (*b.* Groot de Zander, North Brabant, 1853; *d.* Auvers-sur-Oise, 1890) was employed in the branch office of a Parisian art dealer in The Hague, and worked as an assistant teacher and a preacher before finding his way to painting in 1880, more or less on his own. *The Weaver* is an example of the dark pictorial world of his early years as an artist, in which his style was characterized by coarse, vigorous, brushwork. During those years, he combined impressions he had gained from a number of sources: contemporary Dutch painting, the Barbizon School (Millet) Courbet, Rembrandt and 17th-century Dutch painting. This piece was probably the first in a series of paintings of weavers that van Gogh executed during his time in Nuenen. In a letter to his brother Theo, who supported the artist throughout his life, van Gogh wrote: "You will certainly under-

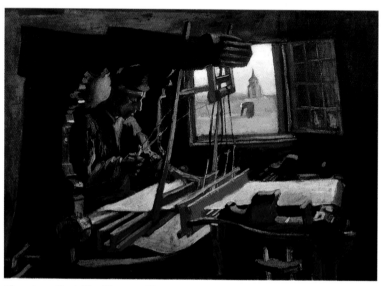

Vincent van Gogh, The Weaver, *1884, canvas, 67.7 x 93.2 cm (14249)*

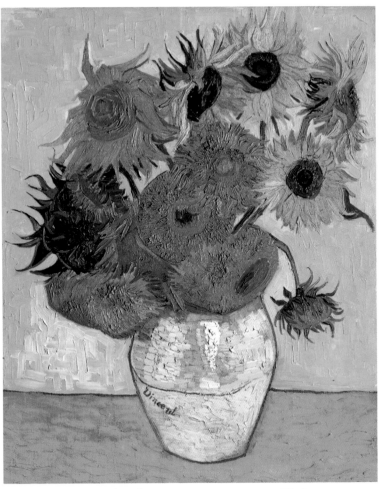

Vincent van Gogh, Vase of Sunflowers, *1888, canvas, 91 x 72 cm (8672)*

stand that I find the world of nature wonderful here. If you come here some time, I shall take you to the weavers' huts. You will surely be impressed by the figures of the weavers and the women winding the yarn." The correspondence with his brother provides a unique insight into van Gogh's artistic existence. Driven by a belief in his mission on behalf of mankind, he veered between creative intoxica-

tion and repeated bouts of despair and was consumed by a yearning for a society of like-minded individuals. The painting depicts the confines of a tiny parlor, which is completely filled by a weaving loom. Through a small window the free, bright world of nature is visible. A woman and a church stand in the distance, symbols of a simple life in which everything has its appointed place.

The *Vase of Sunflowers* was painted in 1888 in Arles, two years after van Gogh had been in contact with Impressionists, Neoimpressionists, Toulouse-Lautrec, Bernard, and Gauguin in Paris. In that city, he discovered a new, light form of color, a clearer kind of formal composition, and a more abbreviated brushwork technique. There he also became acquainted with Japanese printed graphics; as a result, Japan became the land of his dreams because its rich colors and light. In 1888, van Gogh went to Arles, which represented a kind of substitute Japan for him. In this context, he wrote to his brother: "Just look! Is it not almost a true religion that these simple Japanese teach us, surrounded by nature as if they were flowers themselves?" In Arles, he wanted to hang the

walls of his yellow house "with great yellow sunflowers," in joyous anticipation of working together with his friends Paul Gauguin and Emile Bernard.

Van Gogh presents the bunch of flowers in a simple frontal view, setting their heavy yellow heads against a plain background. The intense contrast between the cold, glacier-green turquoise and the yellow of the flowers, blazing like the flames of a fire, turns this simple depiction into the quintessence of pulsating life. That was the impression van Gogh himself stressed when he described his special interest in the suggestive force of color, which had fascinated Delacroix before him. The painting in Munich is one of a series of six sunflower pictures. Later, van Gogh wished to unite them in a

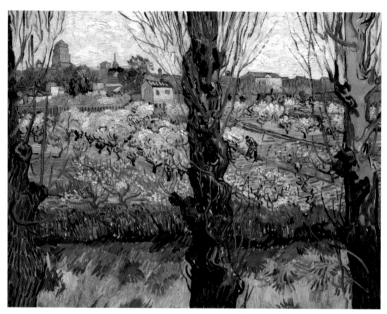

Vincent van Gogh, View of Arles, *1889, canvas, 72 x 92 cm (8671)*

triptych or a polyptych in which they would flank the picture of the *Berceuse* like "torches or candelabra," causing those who stand before them to "feel as if they were being rocked to sleep, as if they were listening to their own lullaby again": form and color combined to suggest a sense of security and well-being.

The *View of Arles* reveals the widening gulf between van Gogh and the joyous abundance of life, steeped in color and light, which he hoped to find in the south. This painting of nature, with blossoming fruit trees, the town and its people nestled within it, is removed from the viewer by watercourse in the foreground and pushed into the distance.

Furthermore, the view is obscured by a rhythmic row of pop-

lar trunks extending beyond the edges of the painting and by the sprays of sprouting branches. By this time, van Gogh's mental illness had become apparent, and he consented to being committed to the psychiatric hospital of St. Remy. The painting also demonstrates the artist's break with Impressionism, and can be seen as a fundamental statement about human loneliness and exclusion from life – one that goes far beyond the depiction of a momentary mood or subjective state of mind.

The *Plain of Auvers* provides an example, of the special brushwork in van Gogh's work a means of expression in itself in the way it structures, psychological elements. This is evident in the swaying crops in the foreground, in the

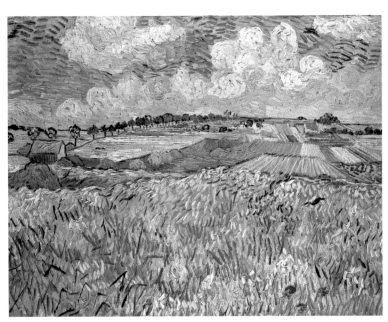

Vincent van Gogh, Plain of Auvers, *1890, canvas, 73.5 x 92 cm (9584)*

Henri de Toulouse-Lautrec, Woman in an Armchair, *1897, cardboard, 63 x 48 cm (8666)*

orderly patchwork of cultivated fields beyond, and, finally, in the short curving lines in the sky, which form billowing clouds. With rhythmic brushwork and bright color, van Gogh creates an image of nature ordered by the human hand; this is echoed by the few vertical elements of the painting: the haystack, the hut, and the row of trees. In addition to conveying a feeling of spring-like freshness through cool pure color, this landscape represents a creative, optimistic appraisal of human existence. Van Gogh painted the picture in Auvers-sur-Oise, where he had gone at the end of May 1890, hoping to find a cure for his illness, and where he was to take his life only two months later.

Henri de Toulouse-Lautrec (*b.* Albi, 1864; *d.* Malromé near Bordeaux, 1901) was the son of an old aristocratic family from the south of France. As a result of two accidents in his childhood, his legs were crippled. In 1882, he went to Paris to train his outstanding drawing ability. While studying with his second teacher, the history painter Cormon, he made the acquaintance of Emile Bernard and Vincent van Gogh. In 1886, Toulouse-Lautrec rented a studio in Montmartre, a district of Paris that, with its revues, music hall, and cafés, provided him with his favourite pictorial themes. He was a regular patron of the Moulin Rouge, which had been newly opened in 1889. Toulouse-Lautrec became a master of

the pointed psychological statement; in this respect, he knew no fear and was indeed fascinated by ugliness. He gained international acclaim for his unmistakable posters and illustrations in which he combined bright yellow and orange colors with sweeping lines, and with which he paved the way for Art Nouveau.

Woman in an Armchair is sketched with concise, swiftly drawn areas of shading in oils on brown cardboard without a ground. The contours of the figure's neck, arms, and upper body, solidify through cross-hatching to create a sense of corporeality. The only part of the picture that is executed in great detail is the lean, delicate face of the woman whose thick hair is pinned up on top of her head. The artist portrays an introverted woman of advanced years, leaning back in her chair in a relaxed manner. The pastel-like softness and coolness of the blue and green tones contrast with the fiery red of the woman's hair, lending her an expression of brooding melancholy.

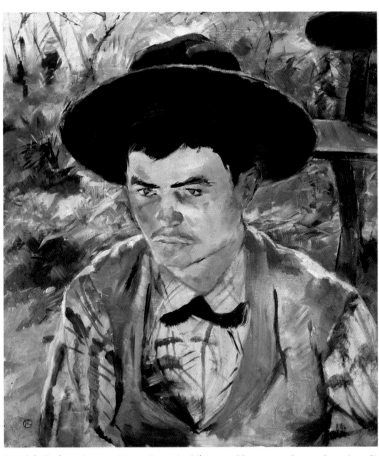

Henri de Toulouse-Lautrec, Young Routy in Céleyran, *1882, canvas, 61 x 49.8 cm (14928)*

Toulouse-Lautrec frequently spent his holidays at Céleyran Palace, the country seat of his grandmother near Narbonne. During his stays there, he drew the landscape, the house, and the people who lived in the area, as various surviving sketches and paintings show. Among these are twelve charcoal studies of the young farm labourer Routy. The drawing *Young Routy in Céleyran* was the final work in this sequence. Routy, probably not much younger than Toulouse-Lautrec, who was seventeen years old at the time, is portrayed from an unusually low angle, close to the ground. His gaze is directed at some point beyond the viewer. His broad, scarcely molded face, bathed in bright light, seems withdrawn if not sullen and brooding. His abbreviated yet intense figure is set against a flat background, consisting of a tangle of pale, lightly sketched plants and a garden bench cut off sharply at the right-hand edge of the paper. Routy's figure seems to be tightly woven into the vegetation in a number of ways: through the gray shadows that flicker across his face and across the plants in the background, in the correspondence between the pattern of his shirt and the vegetation, and, finally, in the parallels between the color of the figure and that of the background with its light gray, ochre and green-blue tones. against which the cool blues of Routy's shirt strike a scarcely perceptible note. Only his coal-black hair and broad-rimmed hat lend him a physical presence and independent identity. The withdrawn figure seems absorbed in thought, caught in a world of light and vegetation.

Auguste Rodin, Eve, 1885(?), terracotta, h. 72 cm (B.355)

Auguste Rodin (b. Paris, 1840; d. Meudon, 1917) is one of the most internationally important and influential sculptors working at the end of the turn of the century. The many conflicting currents that characterize the art of his times are manifest in his œuvre – from Realism and Idealism to Impressionism and Symbolism. Rodin's sculpture reveals his interest in large forms, through which he sought to give expression to man's vital and often tortured existence, torn between spiritual and animal forces. Rodin was also an outstanding portraitist. The distinguishing features of his sculpture are its animated, lively surface; its heavy, sometimes Baroque physicality

presented in vibrant, often ecstatic poses; and its material, which frequently manifests itself in a rough manner alongside and within the modeled form. Rodin created the figure of *Eve*, together with an *Adam*, around 1880–81 for his "Gates of Hell," although they were never used in this context. The tight, self-contained terracotta statuette is distinguished by broken diagonals of an animated contour line related exclusively to the figure itself and to nothing outside it. It is this that lends the sculpture its many different faces, which allow it to be viewed from a number of sides in all its fascinating complexity. The sculpture is an expression of powerful, athletic female physicality, not in the form of idealized beauty, but in all crude, ashamed, distraught nakedness. It is an Eve who seeks to escape the gaze of the viewer. Left to her own devices, she has become aware of her state of distress.

The figure of the *Crouching Woman* moves the viewer with its concentrated, archaic athletic physicality, forcibly restrained in a pose that is both painful and compulsive. In the process, the woman exposes the most intimate parts of her body to the viewer, a circumstance that is reflected in the agonized way she turns her head to one side. In this movement, the bold contours of her body cleave apart diagonally. As a result, the viewer's eye is denied a still point on which

Auguste Rodin,
Crouching Woman,
1880–82, bronze,
h. 85 cm (B.58)

Paul Gauguin, Breton Farming Women, *1886, canvas, 72 x 91.4 cm (8701)*

to rest. It is pulled forward in a revolving, circular movement in its attempt to apprehend the woman's distressing yet libidinous anguish. Rodin's long-time model Adèle posed for this figure, which the sculptor incorporated into larger contexts on occasion. For example, it appears, accompanied by a man, in the group *I Am Beautiful* (1882) and to the left of the *Thinker* in the tympanum of the "Gates of Hell." As an independent sculpture, the work has the title *Lust.*

Paul Gauguin (*b.* Paris, 1848; *d.* Atuana, 1903) spent four years of his childhood in Lima, Peru. After serving for six years at sea, he worked as a bank employee and as a successful stockbroker in Paris. Encouraged by Camille Pissarro, he decided when he was over thirty years of age to take the not so lucrative step from Sunday painter to full-time artist. In 1879, he participated in the fourth exhibition held by the Impressionists, without committing himself to their goals or ideology. Gauguin was also evidently fascinated by the linear style of Degas, by the stylization of Puvis Chavanne, by the planar exoticism of Japanese colored woodcuts, and by primitive sculpture. In 1886, he painted with Emile Bernard in Pont-Avon in Brittany, where the two artists developed a decorative style articulated by bold contours and known as "cloisonnisme."

Breton Farming Women was painted during Gauguin's first stay in Pont-Avon. The bright colors and the application of paint in small areas show that the artist was still pursuing an analytical resolution of

forms through color, as advocated by the Impressionists. The everyday motif of women engaged in conversation over a low garden wall is also consistent with the aims of Impressionism. At the same time, the picture provides evidence of Gauguin's lifelong interest in original, primitive forms and simple ways of life. In addition, the women's broad white bonnets are a token of his increasing attempts to consolidate his forms, to lend them flatness and to extend them in a rhythmic decorative manner over the surface of the picture plane. In this respect, therefore, the painting may be regarded as a key work in Gauguin's artistic development.

In April 1887, Gauguin traveled with Charles Laval to Panama and Martinique. Lack of success and the wish to lead a simple life close to nature were the reasons for this move. But Gauguin fell ill and returned to Paris in November. The *Tropical Landscape on Martinique* is one of the few paintings he made during this period. Here, he applies the paint in remarkably small areas, using short brushstrokes in the same direction; the result is that there are no clearly defined forms anymore. Instead, they are dissolved into a series of soft tonal gradations to produce a shimmering pictorial texture. In this way, an impression of insubstantial, tropical fullness is evoked, in which the signs of life – the women, animals, and huts – merge seamlessly into the natural surroundings.

Paul Gauguin, Tropical Landscape on Martinique, *1887, canvas, 90 x 116 cm (8653)*

Paul Gauguin, The Birth of Christ, *1896, canvas, 96 x 131 cm (8652)*

Gauguin painted *The Birth of Christ* in 1896 on Tahiti, where he had first gone in 1891 in search of an original form of life, free of external constraints. Having returned to the island in 1895, he remained there until his death. This painting was inspired by the birth and subsequent death of Gauguin's son (by a Tahitian woman) at the end of 1896. Here, Gauguin combines a familiar Western genre with native Tahitian forms of depiction. The scene is set in an exotic hut with carved and painted timbers. The animals in the background, however, recall the stable in Bethlehem. This mingling of cultural forms is even more explicit in the group of people at the center of the painting. The dark figure seen in profile, and evidently influenced by depictions of the Maori spirit of the dead, is about to hand the newly born child to an angel with green wings. The woman lying on the bright yellow bedspread in the foreground, with an aureole about her head, can be identified as a South Seas version of the Virgin Mary. A somewhat fainter halo is also visible around the head of the child beside her. Gauguin concentrates the aesthetic attraction of exotic, primitive beauty in the woman, who is reduced to an almost two-dimensional form and set off by radiant colors. At the same time, he invests her with an aura of mystical significance and underlines his intention with a Maori inscription: *te tamari no atua.* Here, Gauguin may erroneously have written "children of God" instead of "child of God," although the plural form could also be an expression of his concept of a mystical, primal religion, in which the native peoples of the earth have a place close to God.

In 1888, **Paul Sérusier** (*b.* Paris, 1863; *d.* Morlaix, Finistère, 1927) was staying in Pont-Avon, Brittany, where he painted with Paul Gauguin and Emile Bernard. In its simplified, two-dimensional juxtaposition of forms, his picture of a *Breton Woman Walking down to Do Her Washing* clearly reveals the influence of Gauguin. Generally, though, Sérusier's vibrant, colored forms are much lighter and more serene than those of Gauguin. As a result, the landscape radiates an easy, untroubled atmosphere.

German Impressionism: *Plein-Air* Painting and Social Realism

Max Liebermann (*b.* Berlin, 1847; *d.* Berlin, 1935) assimilated the most important naturalistic influences of his time and fused them into his own independent language, which he continued to develop throughout his life. The starting point of his career was the drawing tuition he received from Steffeck in Berlin. This was followed by studies at the

Weimar School of Art and at the Düsseldorf Academy under Munkácsy. In 1872, he traveled to Paris, where he was impressed by the *plein-air* painting of the Barbizon School – especially Courbet's and Millet's straightforward depictions of people – and by the pulsating vitality of Delacroix. After 1876, Liebermann traveled almost every year to the Netherlands, where he discovered the contemporary works of The Hague School, as well as the bourgeois art of Frans Hals and Rembrandt. The sober realism of Menzel and Leibl also had an important influence on his development. Liebermann made the acquaintance of these two painters in Munich, where he lived from 1878 to 1884. Ultimately, he was to become the leading mediator between French Impressionist *plein-air* painting and German Realism.

One of Liebermann's key early works in terms of his future development is the *Munich Beer Garden*, a summery *plein-air* painting that depicts a serene, untroubled atmosphere. The scene is set in the

Max Liebermann, Munich Beer Garden, *1883–84, panel, 94.5 x 68.5 cm (14979)*

garden of the Augustiner brewery. People of all ages and all classes of society can be seen under the thick verdant canopy of trees, drinking beer or conversing, listening to the strains of the band or – in the case of the children – playing their games. All of them, regardless of their motley and vividly depicted appearance, are drawn into a densely woven network of light and shade. The crowd of people is animated by splashes of sunlight which seem to materialize, in a manner typical of Liebermann, in pools of light on the ground. The easy, short brushstrokes can be attributed to the painter's familiarity with the techniques of the Impressionists, although he does not seek to emulate the dissolution of form and space into pure light and colour, which was a distinguishing feature of their work. Manet's *Music in the Tuileries Gardens* (1862, National Gallery, London) was an important pre-Impressionist picture for Liebermann in this context. A comparison with Menzel's *Procession in Hofgastein* of 1880 is also instructive. Liebermann attached great importance to his painting and exhibited it in the year of its completion at the Salon in Paris.

The *Woman with Goats in the Dunes* has nothing of the delightful detail that characterizes the *Munich Beer Garden*. With swift, concise brushwork and a subdued palette limited to a few greens and earth tones, nature is here presented as a desolate, monotonous habitat, divided into two clear zones: the pale, attenuated blue of the sky and the dry green of the tough, coarse grass, in which a scarcely discernible path is the only element that gives the painting a sense of direction and depth. The figure of an old woman, seen from the rear, breaks up this spatial continuum. Depicted

Max Liebermann, Woman with Goats in the Dunes, 1890, canvas, 127 x 172 cm (7815)

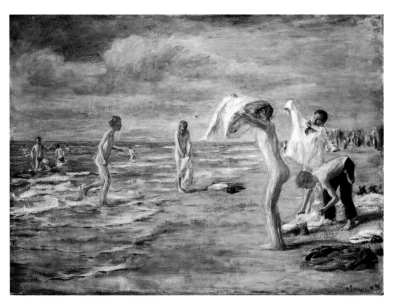

Max Liebermann, Boys Bathing, *1898, canvas, 122 x 151 cm (14679)*

with broad, rough brushstrokes, her terse outline, dull colorless dress, and the resolute strength of her muscular arm, with which she seeks to drag an obstinate goat, convey an impression of her arduous existence. In modest pictorial language, which forgoes all scenic effect and mawkish sentiment, the woman acquires a simple grandeur, which is in keeping with her unpretentious nature. Based on sketches and studies Liebermann brought back from the Netherlands, the picture is one of his masterpieces.
In the year of its completion, he exhibited the painting at the Paris Salon. It was awarded the grand Gold Medal at the annual exhibition in Munich in 1891, where it was purchased for the former Neue Pinakothek.

Liebermann's *Boys Bathing* was also influenced by impressions the painter gained in the Netherlands. In this painting, initial emphasis is placed on the expanse of the sky, the wind, the clouds, and the pulsating rhythm of the sea. The movement of the sea is, in a sense, continued in one last great wave onto the land – in the form of boys quickly retreating from the water and hastily throwing on their clothes. Liebermann captures the immediate mood of this cool northern beach through the use of gray-based blue and green tones. Contrasted with this quiet, homogeneous atmosphere, the pale bodies of the boys, with their white shirts flapping like luminous flags in the wind, are an expression of a high-spirited thirst for adventure and, more generally, a depiction of care-free youth setting out on its journey though life. At the same time, the figures are almost abstract, painted with linear brushstrokes, causing

them to appear as open forms of color and movement. The alternation between spontaneous impression and deeper meaning contained in this painting is typical of German Impressionism. Liebermann worked on the picture until 1896, when he exhibited it in Paris – where it allegedly excited the interest of Degas – and subsequently made certain changes, before applying a final date to it in 1898.

Max Slevogt (*b*. Landshut, 1868; *d*. Neukastel, Palatinate, 1932) studied under Herterich and Diez at the Munich Academy. In 1889, he went to Paris, where he attended the Académie Julian, subsequently returning to Munich. Beginning in 1901, he lived in Berlin, where he had his own masterclass. In 1917, he retired to his country seat in the Palatinate. *In the Evening* is set in the humble dwelling of a young couple. Their evening meal and washbasin stand on the table: dining room and bedroom are one. The portrayal of the two figures goes even further than the description of this simple interior scene. The man is worn by labor, as testified by his bent back and rough hands. The woman is a strangely ambiguous equivocal figure, with her sceptical sidelong glance, somewhere between maidenly innocence and coquettish, calculating womanhood. Slevogt described the picture in a letter to his wife in the following terms: "... and so I am depicting a couple who are sitting together and become, in the first instance, a painting, but in which there should also be room for dark sentiments. Her face, mysterious,

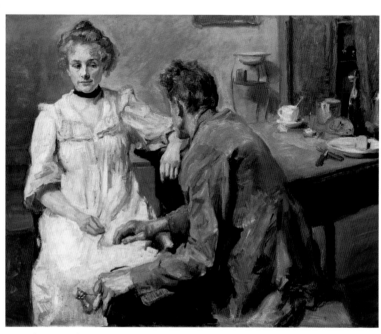

Max Slevogt, In the Evening, *1900–01, canvas, 126 x 155 cm (8181)*

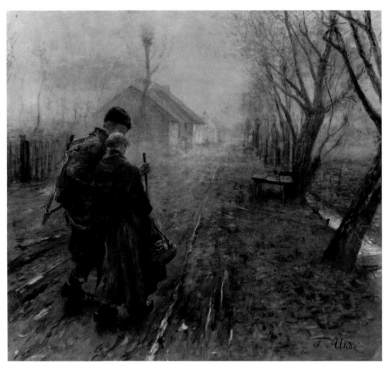

Fritz von Uhde, The Hard Path (The Road to Bethlehem), *c.1890, canvas, 117 x 126 cm (9827)*

capable of many interpretations. His [face] turned towards her. If it has to have a meaning, then something like this: even the poorest have a right to sit at the table of life." The realistic depiction acquires a social overtone through the monumentalization of the figures.

Unlike Slevogt, **Fritz von Uhde** (*b.* Wolkenburg, Saxony, 1848; *d.* Munich, 1911) sought more than just heightenig the man-woman theme by setting it in humble surroundings with a social background. He describes poverty as an act of fate and casts it in a Christian context that is familiar to many viewers. *The Hard Path* shows a

young couple in the foggy dimness of premature dusk. They are walking along a dirty and seemingly endless country road that leads into a village. The two almost seem to merge into a single figure. The woman leans heavily on the man, who bears a saw on his shoulder that identifies him as a carpenter. He supports her solicitously. With oppressive, disturbing effect, the dismal coloration of the picture, restricted to gray and brown tones, suggests an inhospitable winter. An emotional link is created between this desolate, unfriendly landscape – a scene reminiscent of a road in Dachau north of Munich – and the exhausted young couple. In fact, the mood of social realism is

expanded into a modern religious image, to which the subtitle of the picture, *The Road to Bethlehem*, refers. Fritz von Uhde was a cavalry officer who turned to painting relatively late in life. He painted initially in a realistic manner in the style of Munkácsy, under whom he studied in Paris. In Munich, he became friends with Liebermann, who acquainted him with the naturalistic *plein-air* manner of painting inspired by the Impressionists. In Uhde's case, too, these influences manifested themselves in the cool, overcast atmosphere found in Dutch painting. Uhde lived for a number of years in Dachau and in 1892 became a co-founder of the Munich Secession.

In his painting *Sunday Afternoon in Holland*, **Gotthard Kuehl** (*b.* Lübeck, 1850; *d.* Dresden, 1915) depicts a scene of domestic harmony among simple people. The peaceful atmosphere, the clear forms and colors, and the still introspective mood of the figures place this picture firmly in the tradition of 17th-century Dutch interiors by painters such as Pieter de Hooch. A modern feature, however, is the broad treatment of light, intensified here and there by impasto, in which the spatial atmosphere – caught between the light entering from outside and the darkness within – becomes the real focus of interest in this painting. This dramatic handling of light reaches its climax in the girl's crim-

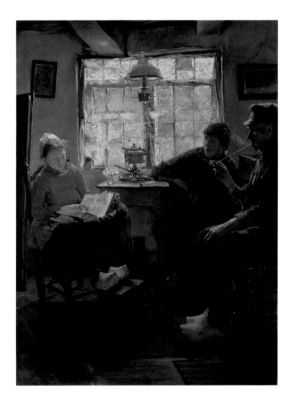

Gotthard Kuehl,
Sunday Afternoon in
Holland, *c.1890,*
canvas, 82 x 61 cm.
(7831)

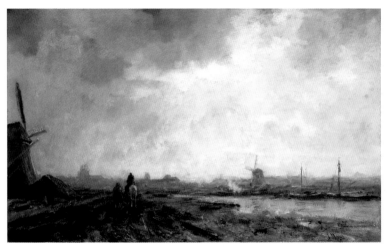

Jacob Maris, Dutch Landscape with Towman, *1890–91, canvas, 85 x 134 cm (7838)*

son smock, which catches the day-light and gleams brightly in the gloom of the interior. In other words, the picture communicates a special atmosphere based on the effects of light. This was a typical feature of Kuehl's painting in the 1890s, in which he increasingly dispensed with narrative, genre elements. Kuehl studied at the Düsseldorf Academy and, from 1870, at the Munich Academy, where he was in the masterclass of Wilhelm Diez (as were Slevogt, Trübner, and Hölzl). During the ten years between 1879 to 1889, he lived mainly in Paris and was in close contact with Impressionism. In Germany, Liebermann and Leibl were influential for his work. Like Uhde, Trübner and Stuck, Kuehl was a co-founder of the Munich Secession.

Jacob Maris (*b.* The Hague, 1837; *d.* Karlsbad/Karlovy Vary, 1899) was an important representative of The Hague School, which had a great influence on German Impression-ism. Maris attended the academy for drawing in The Hague and later, together with his brother Willem, the academy in Amsterdam. In 1864, he moved to Paris, where he was a pupil of Hébert. In that city, however, he was mainly concerned with figure painting. The land-scapes for which he is typically known, set beneath a broad, over-cast Dutch sky, were painted only after he returned to The Hague in 1871. His *Dutch Landscape with Tow-man* depicts a flat area of land in which there are only a few vertical accents: windmills, masts of the boats, and a towman with his hors-es. The picture is, therefore, domi-nated by the sky, the water, and the moist green vegetation along the river. This atmospheric impression, captured with light, easy brushwork and relatively bold colors – above all, a bright green – is typical of Jacob Maris's later work. The influ-ence of 17th-century Dutch land-scape painting is again evident

Max Slevogt, Sunny Corner of a Garden, *1921, canvas, 90 x 110 cm (9094)*

here, with echoes of Jacob van Ruisdael and Philips Koninck, for example, whose work Maris had studied in Amsterdam and The Hague, and who were also greatly esteemed in Paris by the painters of the Barbizon School.

Max Slevogt's *Sunlit Corner of a Garden* is an example of his light *plein-air* painting unattached to a specific theme. In this relatively late work, the painter is concerned with capturing the midsummer mood of the garden of his country seat in Neukastel. The light serves as an important means of uniting the various forms in the painting, causing the plants and flowers to coalesce into a mass of vibrating foliage. In this work, however, Slevogt cannot be comprehended solely in terms of impressionistic formal elements. In

the disproportionately steep slope of the picture plane and the potential ambiguity of the pictorial structure – the way it revolves around the circular table – there are signs of an expressionistic form and space.

Along with Liebermann and Slevogt, **Lovis Corinth** (*b.* Tapiau, East Prussia, 1858; *d.* Zandvoort, Netherlands, 1925) is the third main representative of so-called German Impressionism. His *Fishermen's Cemetery in Nidden* is set beneath a dark canopy of pines, from whence there is a view to the sea animated by the white of the sailing boats in summer. The subdued, melancholy mood of the painting is determined by the cemetery in the foreground, where grave sight crucifixes dissolve into the sombre green

Lovis Corinth, Fishermen's Cemetery in Nidden, *1893, canvas, 113 x 148 cm (12043)*

of the vegetation. As a result, the impressionistic view beyond this seems to be a symbolic reflection on the finite nature of human life and the way it forms part of Creation.

Corinth initially attended the Königsberg Academy (today, Kaliningrad) before moving to Munich in 1880. Following a brief stay in Antwerp in 1884, he studied at the Académie Julian in Paris. After a period of moving back and forth between Berlin and Munich, he settled in Berlin in 1899, where he became a member of the Secession and later its president, after the resignation of Liebermann. The *Portrait of Eduard Count von Keyserling* is an outstanding example of Corinth's abilities as a portraitist. The Baltic aristocrat – a writer belonging to the circle around Max Halbe in Munich – is here portrayed in a trenchant, pointed manner that borders almost on caricature. Corinth, who also associated with this circle of writers, was not interested in depicting the social rank or character of his subject. Rather, he presents a spontaneous psychological portrayal of this pale, blue-blooded man of letters, in whom nervous frailness, if not sickliness, is concealed beneath a nonchalant, almost bohemian outward appearance. This is suggested by his crumpled, wrongly buttoned suit and soft brown hat. Nevertheless, von Keyserling is not presented without a certain claim to social standing – evident, for example, in his golden signet ring. This portrait is full of contradictions – the sensual mouth in a careworn, cerebral

Lovis Corinth, Portrait of Eduard Count von Keyserling, *1901, canvas, 99.5 x 75.5 cm (8986)*

face; the introverted appearance underlined by a narrow-shouldered body and folded arms and legs, and yet there is an expression of character in the protruding, moist, red lips and the watery blue eyes, opened wide as if in amazement. Keyserling, an extremely sensitive person who suffered from a spinal disease, was the author of a book on the atmospheric impressions of his Baltic home.

International Art around 1900

At the turn of the century, the world of art began to divide into a number of separate movements. A hundred years earlier, the central concern had been "merely" to find a new and immediate artistic language that would allow a contemporary representation of the human condition that was simultaneously bound to tradition and accepted rules of art. By the end of the century, however, the main preoccupation was the fundamental role art itself was meant to play. Around 1900, there is already evidence of the division between so-called figurative and abstract art and a polarization of different attitudes. On the one hand, was a form of artistic expression that placed mankind and grand existential themes at the center of its pictorial preoccupations – though often with only a superficial analysis of the problems involved. On the other hand, there was a form of art that retreated into a discussion of issues such as color and form, communicating itself to the viewer indirectly through reflections on itself and its outward relationships.

In terms of the present collection, the most important movements prior to Fauvism, Cubism, and German Expressionism – represented by the *Brücke* and *Blauer Reiter* groups – are Symbolism, Neoimpressionism, and Art Nouveau, or *Jugendstil* as it is known in the German-speaking world. Art Nouveau was a movement that, in its process of reduction, sought a functional and aesthetic understanding of form. As such, it played a central role in the efforts to reform contemporary living conditions and it exerted a strong influence on the various spheres of applied art. The fashion for all things Japanese, which was introduced in Paris in the 1860s, is significant in this context, especially for the motifs it provided in the field of surface ornament.

At the turn of the century in Germany, academic routine caused many young artists to liberate themselves from art loaded with traditional values in favor of fresh artistic expression in various groups commonly known under the name "Secession." The movement manifested itself, for example, in a new yearning for nature. This represented a reaction to the rapid modernization of all areas of life, which was accompanied by a hitherto unseen increase in urban density during the *Gründerzeit*, the period of industrial growth in Germany after the Franco-Prussian War of 1870–71. The background and inspiration for this kind of "nature art" was provided by the spare, restrained painting of the Barbizon School. The best-known haven for this line of development in northern Germany was the artists' colony in Worpswede. Dachau, not far from the cultural centre of Munich, became the main point of attraction for artists in southern Germany.

Ludwig Dill (*b.* Gernsbach near Rastatt, 1848; *d.* Karlsruhe, 1940) was fond of painting misty landscapes in the Dachau Moor – at that time an inhospitable, thinly inhabited plain northwest of Munich. He depicted the motifs he found there in a decorative and stylized manner. *Poplars in the Amper Meadows* is distinguished by the slender outlines of the tree trunks swaying gently in the fog. Their ornamental, sinuous outlines, held in a state of tension, may be seen in relation to the forms of Art Nouveau. In the 1870s, Dill had studied at the Munich Academy under Piloty, among others. Of greater importance for his development, though, was the landscape painting of the circle around Adolf Lier. Dill was president of the Munich Secession from 1894 to 1899. In 1897, he moved to Dachau, where he founded the New Dachau artists' colony together with Hölzl and Langhammer.

Ludwig Dill, Poplars in the Amper Meadows, *1901, cardboard, 93 x 73 cm (8336)*

In the Moor by **Fritz Overbeck** (*b.* Bremen, 1869; *d.* Bröcken near Vegesack, 1909) also exhibits a pronounced decorative and ornamental style. This reveals itself less in the individual cloud formations or the silhouettes of the trees on the horizon than in the splendidly radiant color, based on the contrast of complementary colors like blue and orange. Overbeck worked motifs from the Worpswede landscape into this painting, without seeking to achieve an accurate depiction of the natural world. Here, he is more concerned with capturing an impression of the self-renewing purity of nature. Overbeck studied at the Düsseldorf Academy and became a leading figure in Worpswede, where he lived from 1894 to 1906.

Despite his premature death, **Albert Weisgerber** (*b.* St. Ingbert, Saarland, 1878; *d.* Fromelles, Belgium, 1915) left behind an *oeuvre* of amazing breadth. His *Somali Woman*, for example, has its origins in Art Nouveau, but it also reveals his preoccupation with contemporary art movements in Paris and with the Japanese fashion of the time. The reclining dark-skinned beauty and her stylized representation in broad, two-dimensional areas of color reveal Weisgerber to be more deeply indebted to Matisse than to Gauguin. The influence of Matisse is apparent in the way spatial, material and psychological aspects are subordinated to expressive, direct color. But Weisgerber emphasizes other elements, too. He presents the woman as a sensuous being enveloped in dark red tones

Fritz Overbeck, In the Moor, *c.1904, canvas, 157 x 200 cm (8335)*

often specific to the material from which her heavy, bulky jewelry gleams. Above all, though, his interest is concentrated on the pensive mood of his subject, concealed in her ample robes and offered up on display. The fascinating, even barbaric, otherness of this woman lends the indeterminate figure of the naked, dark-skinned girl in the

Albert Weisgerber,
Somali Woman, *1912,
canvas, 134 x 131 cm
(8693)*

background – a form between primitive sculpture and human being – an enigmatic presence.

By comparison, Weisgerber's *Woman Lying in a Hilly Landscape* is composed of smaller, more agitated, forms and a markedly cooler palette. Here, there is an even stronger dialogue with Cézanne than with Matisse. Again, the central motif of the painting is a reclining female. In this case, however, she is explicitly monumentalized. She may be regarded, alternately, as a sensual nude and as a powerful, self-contained expression of beauty, removed from the viewer's reach and integrated into the background landscape by the cold blue cloth on which she lies. This female figure may be seen in the context of Weisgerber's depictions of Amazons dating from this time, but it is also a token of the painter's unceasing efforts to merge an image of man with a modern form of artistic expression.

With *Water Lilies* or *Nymphéas*, **Claude Monet** (*b.* Paris, 1840; *d.* Giverny/Seine, 1926) would seem to forge a link between Impressionism – of which he was the leading figure – and the abstract art of the 20th century. His paintings of water lilies were conceived as large-scale murals, for which the painting in Munich is a preliminary study. In these works, Monet immerses himself in a self-contained cosmos of floating colors and forms that alternate between substance and insubstantiality, light and shade. Here, there is no inside and outside any more, no above and below, no near and far. At an advanced age, Monet conjures an intangible, dream-like world of water and light, within which forms coalesce into colored patterns that are the sole content of the picture. These paintings represent a wholly sensuous, almost meditative distillation of his lifelong preoccupation with visual impressions. Like Degas, Monet, who was

Albert Weisgerber, Woman Lying in a Hilly Landscape, *1914, canvas, 121 x 136 cm (8885)*

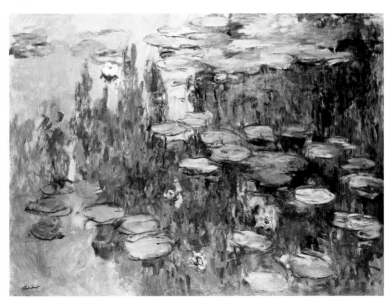

Claude Monet, Water Lilies (Nymphéas), *c.1915, canvas, 140 x 185 cm (14562)*

bitterly poor at the beginning of his career, lived to witness the success of his paintings and their entry into the galleries of art. Suffering from an eye disease, he retired to his country house in Giverny, where, in a constant struggle with questions of form and in fear of going blind, he painted only motifs from the artificial paradise of his garden.

The bronze of *Gustav Mahler* by **Auguste Rodin** (*b.* Paris, 1840; *d.* Meudon, 1917) was sculpted at the instigation of Carl Moll, Alma Mahler's step-father, who moved in the circle around Matisse in Paris. In her memoirs, Alma Mahler-Werfel describes Rodin's special technique of articulating form from a three-dimensional core, instead of removing the superfluous material from the outside in the usual way: "His manner of working was different from that of other sculptors I

had the opportunity of watching. He first created broad surfaces in the rough form of his model and then applied small balls of clay,

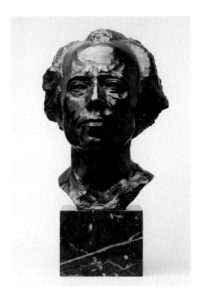

Auguste Rodin, The Composer Gustav Mahler, *1909, bronze, h. 33 cm (B.52)*

which he was constantly rolling while he was talking. ... After we had left, he would smooth the new irregularities. And the next day, he would apply further material."

Rodin portrays Gustav Mahler here as a visionary figure: a man of genius, full of creative power, with sensitive, expressive features. When Rodin was modeling Mahler's head, he remarked on its similarity to the death mask of Frederick the Great and the mummy portrait of Ramses II. Later, Rodin created a stylized marble bust that bore a certain resemblance to this portrait of Mahler and which he gave the title *Mozart*.

The Nabi Group of artists formed in 1888 had its origins in the circle of friends around Paul Sérusier at the Académie Julian in Paris during the 1880s. (The name comes from the Hebrew word meaning "prophet" or "enlightened one.") Dissatisfied with Impressionism and the signs of its decline into triviality and superficiality, the Nabis sought a form of artistic expression that would have a new significance and a deeper, more symbolic content, color, and form in the manner of Gauguin. It was to be distinguished by an archaic, two-dimensional pictorial language. The group included Paul Sérusier, Pierre Bonnard, Maurice Denis, Edouard Vuillard, Felix Vallotton, and other artists, as well as musicians and writers. Maillol was also closely allied to the Nabis.

Maurice Denis (*b.* Granville/ Manches, 1870; *d.* Paris, 1943) was the theoretician of the group. His painting *Gallic Goddess of Flocks* is

Maurice Denis, Gallic Goddess of Flocks, *c.1905, cardboard, 80 x 68 cm (8654)*

Pierre Bonnard,
Lady at the Looking
Glass, *c.1905, canvas,*
52 x 37.5 cm (8665)

striking for its combination of
rhythmic vertical elements (the tree
trunks) and small-scale areas of
infilling (the vegetation) into a rich,
tapestry-like surface. Only the walls
in the foreground have an explicitly
three-dimensional weight. The fig-
ure of Epona, the Gallic goddess of
the flocks, is attired in plain, radi-
ant white and raised in state on her
horse. In view of the way she is
depicted in continuous areas of
bright color, she represents the
focus of the pictorial composition.
Nevertheless, she is scarcely grasp-
able in any substantial form and is
graphically transposed into a fasci-
nating depiction of a natural garden
reminiscent of paradise. As a result,
she would seem to serve more as a

diffuse vehicle for the evocation of
atmosphere than as a significant
title figure.

Pierre Bonnard (*b.* Fontenay-aux-
Roses, 1867; *d.* Le Cannet near
Cannes, 1947) takes an everyday sit-
uation as his subject for the *Lady at*
the Looking Glass. Any impression
of casual spontaneity is denied by
his concentration on the dark, self-
contained woman and her exclusive
relationship to a dark-framed mir-
ror. Only beyond this does the light,
surface of the wall open up the pic-
ture. Like the room, the woman
assumes concrete form only in the
mirror, where she appears to be
caught in a world of excerpts and
reproduction in which interior and

143

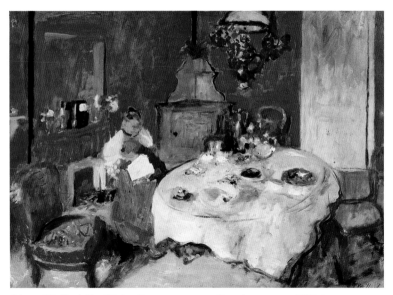

Edouard Vuillard, The Dining Room, *c.1902, cardboard, 53 x 72 cm (8664)*

exterior are inextricably mixed. In other words, the painting is a small but artistic exploration of image, copy, and reflection – or the reality of pictures.

Edouard Vuillard (*b.* Cuiseaux/ Saône et Loire, 1868; *d.* La Baule/ Loire-et-Cher, 1940) came to the Nabis in 1890 through his friendship with Maurice Denis. *The Dining Room* was painted at a time when Vuillard was again receptive to the ideas of Impressionism. The spatial dimension is based on the harmony between the red color of the wall, subdued with gray tones and echoed by the upholstery of the chair and the dress, and the large bright circle of the table. Defined by sinuous, curving forms, the room is a feminine space. Although this is not formulated in detail, it is confirmed by the solitary woman seated at the table and occupied with her sewing. Judging by the way the table

is laid, she might be expecting a visitor, although this is not fundamental to an understanding of the painting. Vuillard was concerned here with colors and forms in a middle-class living room. In their ornamental combination, they serve as an emotional means of describing human relations. The faceless woman is in fact the artist's mother, who, after the death of her husband, provided for the family by working as a *corsetière*. Vuillard lived with her until her death in 1928.

Odilon Redon (*b.* Bordeaux, 1840; *d.* Paris, 1916) did not belong to the Nabi Group, but associated with its members from time to time and made a deep impression on them with his visionary, dream-like, sometimes nightmarish pictorial world. Painted as late as 1912, *The Cathedral*, with its diffuse mystical, religious aura, has a Symbolist background. This is based on the

Odilon Redon, The Cathedral, *c.1912, canvas, 92.5 x 73.5 cm (13080)*

suggestive combination of a familiar spatial situation – evoked by the Gothic rose window and the anguished fugure of the *pietà* – and the intense mood of the light, filtered to a precious glow by the stained glass. In this painting,

therefore, light again plays a central role. However, unlike in the paintings of the Impressionists, here it is a phenomenon that addresses our secret, hidden emotions.

Bonnard's *Lignite Colliery near Terrenoire* was probably intended as part of a large mural commissioned by Thadée Natanson, the head of the colliery described in the title and a patron of the painter. The work was ultimately not accepted, because its execution took too long. The painting presents a view of the landscape with the lignite mine painted in flat forms with simple, strikingly bold coloration. The insertion of the green oasis with children playing in the foreground provides an idyllic undertone to the depiction. The subject was an unusual one for Bonnard, but it bears witness to his activities as one of the leading poster artists alongside Toulouse-Lautrec.

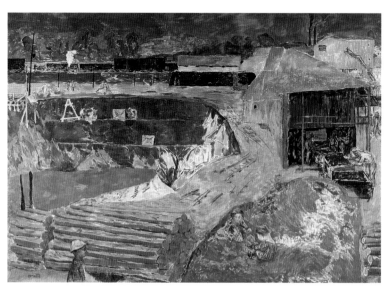

Pierre Bonnard, Lignite Colliery near Terrenoire, *c.1916, canvas, 242 x 337 cm (13721)*

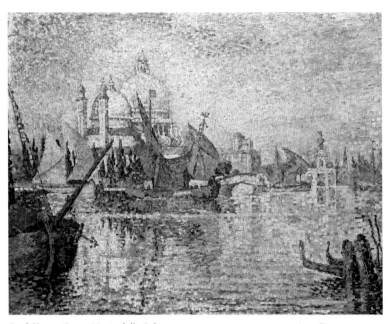

Paul Signac, Santa Maria della Salute, *1904, canvas, 73.5 x 92.5 cm (14758)*

In his early work, **Paul Signac** (*b.* Paris, 1863; *d.* Paris, 1935) painted in a style closely related to that of Monet and Sisley. This was to change rapidly when Signac embraced the style of Neoimpressionism, after his encounter with Georges Seurat in 1884. Seurat, who was deeply interested in the theory of art, had developed a system of color in which small dots of bright pure hues were set next to each other. Seen from a certain distance, the simultaneous and successive contrasts of the colored dots were believed to blend in the eye of the viewer to give much brighter and purer colour values than was possible by mixing the paint on the palette. The church of *Santa Maria della Salute*, with its pair of domes stepped in height, is an important landmark of Venice and a popular motif for painters.

Signac developed his prospect, viewed from the Giudecca, using small, densely clustered patches of boldly colored paint. Particularly in the area of the sailboats, these coalesce to form a resplendent gold-en-red surface pattern, which, in its ornamental character, is reminiscent of Art Nouveau. In the shimmering, radiant colors, matter, water, light, and sky are fused into an atmospheric unity. Henri van der Velde is believed to have designed the white and gold frame.

In his *Still Life in the Studio*, the Belgian painter, writer, and composer **James Ensor** (*b.* Ostend, 1860; *d.* Ostend, 1949) evokes a garish, claustrophobic, and oppressive atmosphere. Ensor depicts the usual painter's props – a palette, brushes, bottles, a mirror, a figure of the human torso with a jointed

James Ensor, Still Life in the Studio, *1889, canvas, 83 x 113 cm (13071)*

doll on its shoulders, books, instruments, and Oriental porcelain. The whole collection of objects is surrounded by, and interspersed with, grinning masks and grotesque faces, including a skull. As a result, the quiet, authentic studio is filled with demonic life – an autonomous in-between world of disturbing fantasy, painted with nervous, vibrant brush strokes.

Ferdinand Hodler (*b.* Berne, 1853; *d.* Geneva, 1918) painted *Those Tired of Living* in Geneva. Unable to afford models to sit for him, he took a number of "down-and-outs" instead, whom he found in the workhouse and on park benches. Hodler portrays five old men lined up on a bench in a strictly symmetrical arrangement and parallel to the picture plane. Attired in white

Ferdinand Hodler, Those Tired of Living, *1891–92, canvas, 150 x 295 cm (9446)*

monastic robes, they sit with bowed heads, their rough hands folded on their knees. The figure in the middle is the only one to break this rigid order. He has no beard and is half-naked; his arms hang down loosely, and his lowered head leans to one side. This variation heightens the stylized monotony of the row and at the same time focuses attention on the realistic portrayal of the heads. The clearly symbolic content of the picture alludes to the stoic anticipation of death of these men, who are already dressed in their shrouds – reduced in the case of the central figure to something resembling a winding sheet. Hodler himself said of this painting: "*Those Tired of Living* are content with their lives, but they are weary and submit acquiescently to what the future will bring. By dressing them in white sheets, I have already set them in the hereafter."

Hodler's *Student from Jena* is a study in oil for one of the figures in *The March of the Jena Students in 1813 to Join the Struggle for Freedom against Napoleon*, a fresco Hodler completed in the hall of the University of Jena in 1909. The study, which is in the nature of a self-contained picture, is striking because of its fluid and exciting resolution of the monumental, vertical format. This is achieved by slender, austere forms and precisely calculated diagonal countermovement, engendered by the act of drawing on the coat and resulting in a figure that is tightly bound into the picture format. Equally convincing is the way the austere, restrained

color serves to relate the figure to the ground. The hard contrast between black and white is broken by the pale violet of the figure's shirt, a consciously vivid and lively tone that spills out to the youthful face and background. Initially composed as a large-scale two-dimensional form, the figure thereby acquires a fascinating, expressive spatial presence.

As a painter, **Giovanni Segantini** (*b.* Arco, Lake Garda, 1858; *d.* Schafberg, Pontresina, Switzerland, 1899) was largely self-taught. At the beginning of his career, he worked as a scene painter in Milan, where he attended evening classes at the Academy for a time. The main theme of his paintings, with which he soon enjoyed international success, was the hard world of the people who lived in the shadow of the Alps. In his straightforward yet noble portrayal of nature, he was clearly influenced by Millet's simple, grand image of man. In *Ploughing*, he depicts a panoramic view of a high valley. Drawn over this scene is the bright veil of spring, which reawakens the thin layer of fruitful soil that has been wrested from nature. The arduous existence of the two farmers ploughing the stony ground with their team of horses is elevated to an image of human nobility. The horizontal accentuation of the broad format itself, the chain of mountains, and the houses of the village spread across the width of the canvas create an immediate sensation of the unity of man with these bare natural surroundings. In his treatment of the forms – a

Ferdinand Hodler, Student from Jena, *1908, canvas, 212 x 92 cm (8643)*

Giovanni Segantini, Ploughing, *1887–90, canvas, 117.6 x 227 cm (7997)*

dense, vibrant network of short lines in unmixed, partly complementary, colors without areas of atmospheric shading – Segantini goes far beyond the perceptions of the Neoimpressionists. With great mastery, he not only conveys a sense of the intense clarity of light in the high Alps, he elevates the scene into an image of sublime radiance.

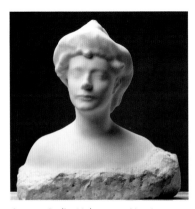

Auguste Rodin, Helene von Nostitz, *1907, marble, h. 54.3 cm (FV 11)*

Among the portrait busts sculpted by **Auguste Rodin** (*b.* Paris, 1840; *d.* Meudon, 1917), that of *Helene von Nostitz* occupies a special place in his *oeuvre* in view of the aura of maidenly beauty that hovers about it. The figure is fascinating for its bud-like form, which emerges from the rough-hewn stone with a firm, youthful smoothness, dissolving into details that are only schematically articulated. These include the areas around the eyes, which appear as if they were veiled, and the framing cloud of hair, which Rodin considered reworking at one point. The animated *chiaroscuro effects* created by the crystalline clarity and translucent purity of the white marble intensify the glow of the skin and the impression of youthful lustre. Helene von Nostitz-Wallwitz, born in 1878 in Berlin, was one of the leading female figures in the Franco-German art world at the turn of the century. She was a writer and a friend of Rilke, Rodin, and Hoff-

Gustav Klimt, Portrait of Margarethe Stonborough-Wittgenstein, *1905, canvas, 180 x 90.5 cm (13074)*

mansthal. She was also acquainted with Max Liebermann, Harry Count Kessler, Max Reinhardt, Henri van der Velde, Gerhart Hauptmann, Julius Meier-Graefe, and Carl Sternheim.

In the flat backgrounds of his painting, stylized with precious mosaic-like surfaces and often highlighted with areas of gold, **Gustav Klimt** (b. Baumgarten, Vienna, 1862; d. Vienna, 1918) provides an outstanding example of the way the boundaries between various forms of art were dissolved in Art Nouveau at the end of the 19th and the beginning of the 20th century. As Klimt himself remarked, Art Nouveau or *Jugendstil* represented the "permea-

tion of the whole of life with artistic designs." In his *Portrait of Margarethe Stonborough-Wittgenstein*, a tall, slim woman is set theatrically against a backdrop of this kind. The only spatial quality in the picture is the dark mosaic strip that marks the line between floor and wall. The woman possesses three-dimensional substance only in the portrayal of her head and interlocked fingers. The effect created by the soft, flowing richness of her gossamer silk dress – probably from the Viennese design workshops – is based on a reciprocal action between the ornamental pattern and the innate character of the material. As a result, the only point at which the soft, almost insubstantial brightness of the dress and the woman's alabaster-like, refined form overlap is in the area of her head with its dark hair and expressive eyes. The subject, who was twenty years old when this portrait was painted, was the sister of the philosopher Ludwig and the pianist Paul Wittgenstein. In this work, she is an aesthetically exalted, stylized modern beauty.

Klimt received his training at the school for arts and crafts in Vienna. Together with Joseph Maria Olbrich and Josef Hoffmann, he founded the Viennese Secession in 1897 and was its president until his resignation in 1905.

Egon Schiele (*b*. Tulln, Lower Austria, 1890; *d*. Vienna, 1918) died at the early age of twenty-eight of Spanish flu. Within the space of only ten years, he created a remarkable œuvre. His friendship with Gustav Klimt was important for his early artistic development, as Klimt's ornamentation had a strong influence on the younger artist. Seen in this light, *Agony* may be regarded as a cryptic double portrait of the two men. The painting portrays a young monk lying on a bed, his sunken eyes and

Egon Schiele,
Agony, *1912,*
canvas,
70 x 80 cm (13073)

Edvard Munch, Village Street in Aasgaardstrand, *c.1902, canvas, 59.8 x 75.8 cm (11709)*

emaciated face clearly marked by death. At his side kneels the powerful figure of an older, bearded monk. The figures and the picture plane are articulated by interlocking areas of color, defined by black outlines, and have a three-dimensional structure. The composition is held together by the tonal duality of ochre and vermilion – a typical feature of Schiele's work which lends the surface pattern a dark, warm glow. At the same time, it is disturbingly permeated by nervous, angular, broken lines, which seem to have an independent existence. The two figures appear to be linked by flat, interrelated areas of color. Ultimately, however, they prove to be divergent poles: one is depicted as resolute and persevering, the other as dynamically withdrawn.

Together with Gauguin, van Gogh, and Cézanne, **Edvard Munch** (*b.* Löten, 1863; *d.* Ekely near Oslo, 1944) was one of the most important precursors of Expressionism and Modernism. His boldly colored visual language, with its psychological undertones and emotionally charged brushwork, made Munch a pioneering figure. In his pictorial world, he lent expression to the existential problems of modern man. *Village Street in Aasgaardstrand* depicts a woman in a red dress and light-colored hat at the edge of a curving pink band of road. Faceless and anonymous, she stands alone, separated from the houses of the village by an anthropomorphic, but incomprehensible, dark body of colors on the right. This form introduces an unexpected and ominous element

into a painting that, at first glance, seems to be composed of bright, radiant colors. The happy village scene is thus transformed into a reflection on an inner psychological state.

Franz von Stuck (*b*. Tettenweiss, Lower Bavaria, 1863; *d*. Munich, 1928) was the second great painter-prince of the *Gründerzeit* in Munich after Lenbach. Stuck's magnificent villa, in which *Jugendstil* and Renaissance elements are synthesized, still stands in Prinzregentenstrasse. Stuck studied at the school for arts and crafts in Munich and later at the Academy.

Böcklin and Lenbach were the most influential figures in his artistic development. He was one of the founders of the Munich Secession in 1892, and he created an extensive body of applied graphic art for the magazine *Die Jugend*, from which the term *Jugendstil* derives. *Sin*, his most famous work, of which there are eight versions, is based on a highly charged erotic and symbolic theme that was typical of this painter. Eternally seductive woman is depicted here in the form of a demonic being, lasciviously embraced by a serpent as was the biblical Eve – the incarnation of the female power of

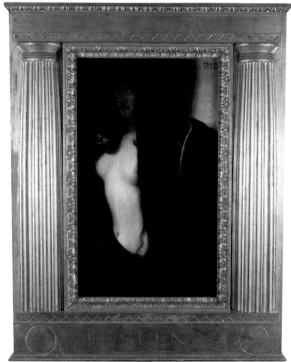

Franz von Stuck, Sin, 1893, canvas, 88.4 x 53.4 cm (7925)

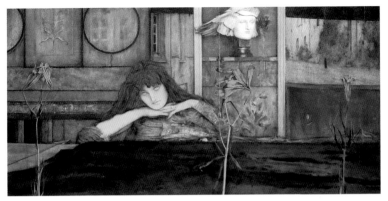

Fernand Khnopff, I Lock the Door upon Myself, *1891, canvas, 72 x 140 cm (7921)*

temptation. Enveloped in a mysterious cloak of darkness and set ambitiously in a gilded frame that combines *Jugendstil* decoration with strict Renaissance forms, the depiction raises the male eye to the altar of its desire.

Fernand Khnopff (*b.* Krembergen, Western Flanders, 1858; *d.* Brussels, 1921) was the leading representative of Belgian Symbolism. After studying at the Brussels Academy, he went to Paris, where he was deeply impressed by the work of the Pre-Raphaelites exhibited at the World Exhibition in 1878. The painting *I Lock the Door upon Myself* is one of his principal works. In an irrational and discontinuous space articulated by round mirrors, dark blinds, closed windows and a painting, a woman can be seen resting her head on two hands. Her most striking features are her long, flowing red hair and her uncannily bright, open-eyed expression. Withered orange lilies, poppies, the head of Hypnos – the god of sleep in antiquity – and an arrow aimed at the woman evoke a mystifying atmosphere in which elements of sleep and dream, pain, transience, and death manifest themselves, all captured in a subdued, aesthetic colors. In the title of the picture, Khnoppf cites a line from a poem by Christina Georgina Rossetti, the sister of the leading Pre-Raphaelite, Dante Gabriel Rossetti. The poem, dating from 1864, describes a nun's renunciation of the world. In 1891, Khnoppf traveled to England, where he made the acquaintance of Rossetti, Burne-Jones, and Watts.

Aristide Maillol (*b.* Banyuls-sur-Mer, 1861; *d.* Banyuls-sur-Mer, 1941) is, next to Rodin, the best-known French sculptor in the period of early Modernism. Unlike Rodin, however, he pursued a path of strict, stylized naturalism. His works possess the measured calm of classical antiquity and a clearly defined point of view. At the beginning of the 1880s, having trained

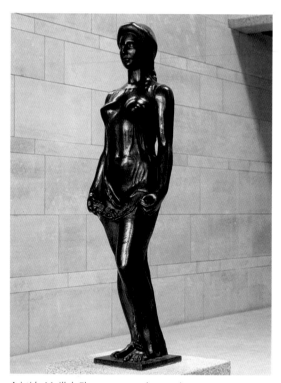

Aristide Maillol, Flora, 1910–12, bronze, h. 163.5 cm (including plinth) (B.154)

initially as a painter, Maillol came into contact with the Nabis and the circle of artists around Gauguin. He finally decided to devote himself to sculpture in the mid-1890s. *Flora* was created for a commission from the Russian collector Morosoff as part of a cycle of the seasons. The clear, compact, sculptural quality of this work with its restrained contours exhibits a sense of vigor and tension. The undulating silhouette, swelling into increasingly powerful curves as it rises, is an expression of burgeoning fullness and maturity. Despite the limited individuality of the figure – Maillol often worked without a model – the contrast between its formal reduc-

tion and the naturalistic effect of the thin garment draped over the body exerts a great attraction. In its soft, bunched folds, the chemise lends the figure a trace of ornament at various points.

Max Klinger (*b*. Leipzig, 1857; *d*. Grossjena near Naumburg, 1920) met *Elsa Asenijev* in 1898. For almost twenty years, she was Klinger's model and companion, and they also had a daughter together. The author Elsa Asenijev came from an upper-class Austrian family. She was initially married to a Bulgarian diplomat, and she played a leading role in the feminist movement of her time. Unlike

Rodin's *Helene von Nostitz*, this extravagant woman is portrayed in Klinger's sculpture as an enchanting, fascinating person, but with a formidable presence. All of these attributes are produced from the combination of various kinds of stone and the colorful surface attractions – from the lively, almost uncontrolled mass of her hair to the penetrating blue pupils of her eyes. The sculpture may therefore be seen as an embodiment of womanhood itself, a portrayal of *femme fatale* – half child, half woman – at the turn of the century, a figure who draws the (male) observer under her spell while experiencing her irresistible charms.

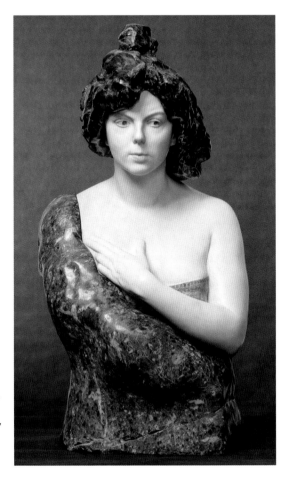

Max Klinger, Elsa
Asenijev, *c.1900,*
Parian marble with
residual coloration
(exposed parts of body),
inset opals (eyes),
Pyrenean marble (hair),
polychrome marble
(drapery), h. 92 cm
(B.739)

Index of Artists

Bayerische Staatsgemäldesammlungen
Neue Pinakothek
Barer Straße 29
(enter from Theresienstraße)
80799 Munich
Tel. +49 (89) 23 805-195
Fax +49 (89) 23 805-221

Photos: pages 16, 17 bottom, 20 top, 25, 27, 34 bottom, 35–37, 40 bottom, 41, 48, 49, 54,
56 bottom, 57–59, 62 top, 72–74, 77–79, 81, 83, 89, 91, 110, 115, 124, 128, 131, 135, 139 top,
150 top: Artothek, Peissenberg
All other illustrations were taken from the archives of the Bayerische Staatsgemäldesammlungen

Front cover: Edouard Manet, *Breakfast in the Studio*, 1868, detail from the illustration on p. 104
Back cover: The exterior of the Neue Pinakothek, photo: Jens Weber

The Publisher would like to thank Artothek for kindly providing pictorial material for this guide-
book

Prestel Verlag
Mandlstrasse 26, D-80802 Munich, Germany
Tel. +49 (89) 38 17 09-0, Fax +49 (89) 38 17 09-35;
4 Bloomsbury Place, London WC1A 2QA
Tel. +44 (0171) 323-5004, Fax +44 (0171) 636-8004;
and 16 West 22nd Street, New York, NY 10010, USA
Tel. (212) 627-8199, Fax (212) 627-9866

Prestel books are available worldwide.
Please contact your nearest bookseller or write to one
of the above addresses for information concerning
your local distributor

Library of Congress Cataloging-in-Publication Data is available for this title

Translated from the German by Peter Green, Munich
Copyedited by Courtenay Smith, Munich
Layout and design by Verlagsservice G. Pfeifer, Germering
Typeset by EDV-Fotosatz Huber, Germering
Lithography by ReproLine, Munich
Printed and bound by Passavia Druckservice GmbH, Passau

Printed in Germany on acid-free paper

ISBN 3-7913-2240-0